BRIDGEWATER CANAL

THROUGH TIME

Jean & John Bradburn

AMBERLEY

First published 2016

Amberley Publishing
The Hill, Stroud, Gloucestershire, GL5 4EP
www.amberley-books.com

Copyright © Jean & John Bradburn, 2016

The right of Jean & John Bradburn to be identified as the
Authors of this work has been asserted in accordance
with the Copyrights, Designs and Patents Act 1988.

ISBN 978 1 4456 5926 8 (print)
ISBN 978 1 4456 5927 5 (ebook)

British Library Cataloguing in Publication Data.
A catalogue record for this book is available from the
British Library.

Origination by Amberley Publishing.
Printed in Great Britain.

Introduction

The story of the Duke of Bridgewater's canal is one of personal sorrow, willpower and engineering genius. It is known as England's first canal and marked the beginning of a transport revolution. There had been earlier inland navigations, such as the Mersey and Irwell Navigation, but they used an existing watercourse or river. The duke's canal was the first to be built independently of other rivers.

His father, Scroop Egerton, 1st Duke of Bridgewater, was the first to try to solve the problem of transporting coal from his mines by building a navigable waterway from Worsley to Manchester. Nothing came of this venture. Francis, a sickly child, succeeded to the title at the age of twelve in 1748. In 1753 he, like so many privileged young men, took the Grand Tour of France and Italy. Meanwhile, Samuel Egerton of Tatton was appointed receiver of the rents and profits of the family estates in Worsley. It has been suggested that seeing the Royal Canal in Languedoc was inspiration for his subsequent enterprise. There is no doubt that Louis XIV's canal, which traversed the whole of France, must have been an impressive sight.

Like all men of high status, it was essential to marry and produce a male heir. Sadly, a happy marriage was not to be for Francis. Having failed in love, he pursued his vision for a canal with great strength of character. His personal habits shocked his aristocratic relatives, for he swore often, failed to wash regularly and paid scant attention to the conventions of polite society. But he was well thought of by his employees for, although strict, he was frequently kind, and gave better wages and conditions than most.

He was at first occupied with solving the problem with his mines, namely drainage and the movement of coal. He met with John Gilbert, the mine's agent, and the following year Gilbert introduced James Brindley to the duke. This meeting of three great men was to bring about a feat of great engineering. Remember, this was 1759 and James Watt's steam engine and other inventions were still a decade or more away.

He had to achieve Acts of Parliament to cut across the estates of the many landowners and this involved determination to achieve success. To achieve the route through to Manchester, the duke had to purchase the Hulme Hall Estates for £9,000. The added expense of building warehouses at Castlefield resulted in a considerable personal debt. This was only the beginning. To reduce expenditure, he was forced to close Bridgewater House in London and reduce his servants.

While the route through to Manchester was proceeding, plans were made for a route through Cheshire to link up with the Mersey. Here

the project faced the problem of gaining the consent of the Trafford Estates, Stamford Estates, the Leghs of High Legh, Sir Richard Leycester of Tabley and, the biggest problem of all, Richard Brooke of Norton Priory. Richard managed to block his plans for many years and the duke was only able to complete the canal through Norton by changing the route quite dramatically.

Runcorn Locks were opened on 1 January 1773 but a mile of canal was yet to be dug at Norton. By this time James Brindley had been dead for three months, so John Gilbert had to finish the work and the canal to Manchester was complete in 1776.

In 1795, the Fifth Bridgewater Canal Act sanctioned the extension from Worsley to Leigh. The duke was now sixty years old, but he saw the advantage of linking up with the Wigan branch of the Leeds and Liverpool Canal. This would provide a through navigation between Lancashire and Cheshire and beyond. The Act enabled him to extend the canal a further 5 miles from Worsley via Boothstown, Astley Green and Bedford to Leigh. The new extension enabled the supply of coal from Leigh and the surrounding districts to Manchester. On 21 June 1819 a further Act of Parliament was enacted to create a link between this extension and the Wigan branch of the Leeds and Liverpool Canal.

By the 1840s, the trustees of the Bridgewater Canal could not fail to see that competition from the railways was a distinct threat. However, there was a bigger threat looming on the horizon – the building of the Manchester Ship Canal.

Manchester's businessmen had long shown enthusiastic support for a canal that could carry ocean-going ships. They eventually overcame opposition and in 1885 the Manchester Ship Company bought out the Bridgewater Navigation Company for £1.71 million. They had now acquired not only the canal but also its docks and properties.

We have spent all summer walking the canal and have enjoyed the company of the many people who live and holiday on the Bridgewater Canal. Its future is now preserved by the Bridgewater Trust, who now manage the canal. All income generated by the canal from pleasure craft, fishing, drainage and sales of water for cooling purposes is used to maintain and improve the canal and its local environment.

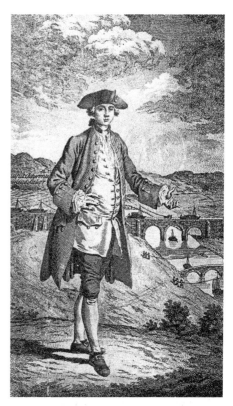

Francis Egerton, 3rd Duke of Bridgewater (1736–1803)

He was the youngest child of Scroop Egerton, 1st Duke of Bridgewater, who owned mine workings at Worsley. What a fine image this is of the young man and his wonderful achievement, the Barton Aqueduct. As he aged, he became large and corpulent – no longer the slim youth we see in this painting. He dressed carelessly and usually wore a suit of brown and dark drab breeches, fastened at the knee with silver buckles.

Elizabeth, Duchess of Hamilton

It is this woman who may have been responsible for Francis to pursue his dream of building the Bridgewater Canal. Francis entered into the life of a fashionable young man enjoying London life. He enjoyed horse racing and, of course, gambling. His personal life would not prove to be happy. After a number of liaisons, his first attempt to marry and produce a male heir was with Jane Revell. The lady was a considerable heiress, but the match came to nothing. He then fell in love with Elizabeth, one of the Gunning sisters, Irish beauties from County Roscommon. He proposed marriage but, sadly, the engagement was again not to last. She jilted him and, less than three months later, married Col John Campbell, cousin and heir to the 3rd Duke of Argyle. Some say that Francis jilted her but we will never really know. Whatever the truth, it prompted Francis to leave London and take up residence in Worsley to devote himself to his estates and plan his canal. He was never to marry. On 8 March 1803, the duke died at Cleveland House after a road accident in his coach brought on a short bout of flu. He was not buried at Worsley but with his forebears at Little Gaddesden, near Ashridge, on 16 March 1803.

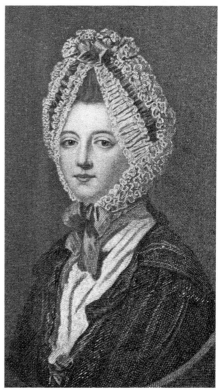

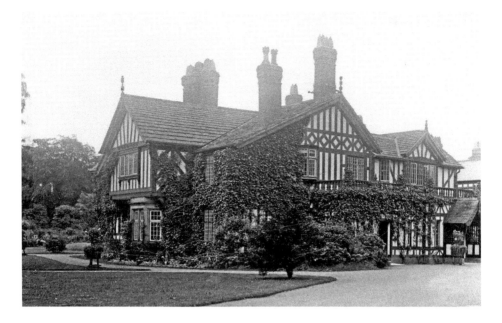

Worsley Old Hall

The story of the duke and his canal involve not one but three halls at Worsley. First built by the Massey family, the lords of the manor of Worsley, Worsley Park and Hall passed from the Masseys to the Brereton family, and then in the seventeenth century to the Egertons. The hall was originally a medieval moated manor site. John Gilbert lived at Worsley Old Hall from 1759, after he came to Worsley as the mine agent to Francis Egerton, 3rd Duke of Bridgewater. It was in this hall that John Gilbert, James Brindley and the duke initially met to discuss their canal strategy. Surprisingly, this is the only hall that is still standing today.

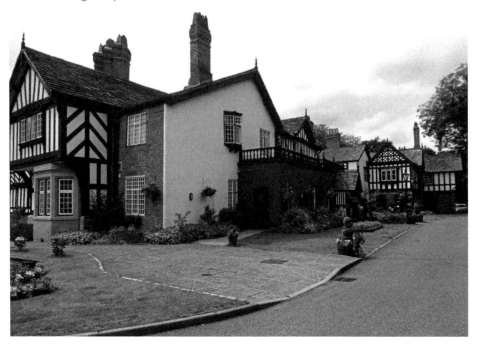

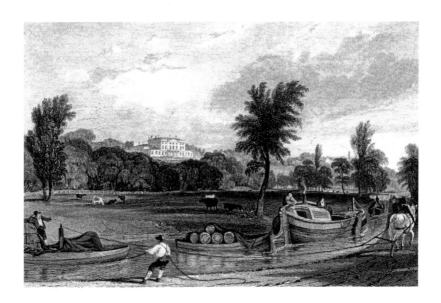

Worsley Brick Hall

Built in the 1760s by Francis Egerton, who was unhappy with the old hall, this Georgian-style building was located north of what is now Leigh Road. It was pulled down between December 1844 and August 1845 as the new hall neared completion. The first occupant was John Gilbert, the duke's agent in Worsley, and the duke described it as 'my steward's house'. It was the setting for a family tragedy when Robert Haldane Bradshaw, superintendent of the estates, named James Sothern as his successor; Robert's son was so distraught that he committed suicide at the hall. Lord Francis Egerton used this tragedy as an excuse to demolish the hall in 1846. This rather old map shows the Worsley demesne of 1776 with the Brick Hall south of the Old Hall near to Leigh Road.

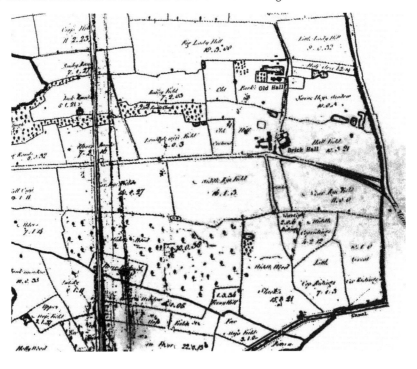

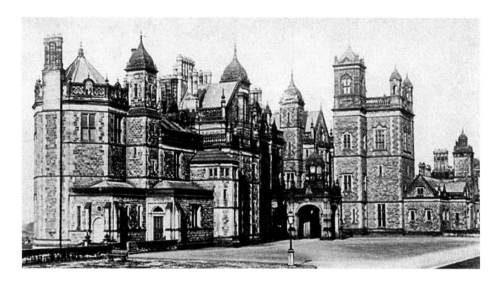

Worsley New Hall

Francis Leveson-Gower inherited the Worsley estates in 1833 and changed his name to Egerton in accordance with his great uncle's will. Soon after his arrival in Worsley in 1837, Lord Francis Egerton decided that both the Old Hall and the Brick Hall were inadequate for his needs and he commissioned the architect Sir Edward Blore to build it afresh. The building was completed in 1846, the year he became 1st Earl of Ellesmere. Its most distinguished guest was Queen Victoria, who stayed at the hall twice – in 1851 and again in 1857. Worsley New Hall was an Elizabethan Gothic-style mansion with fine gardens surrounding the house but sadly it has been demolished. The map of 1904 shows its position south of Leigh Road.

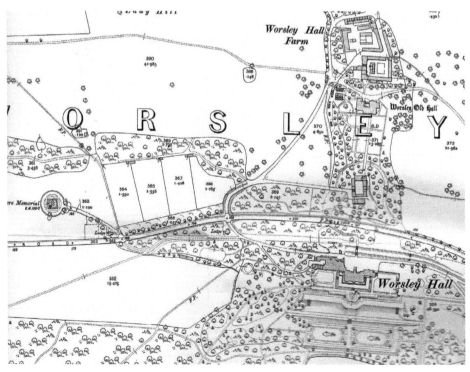

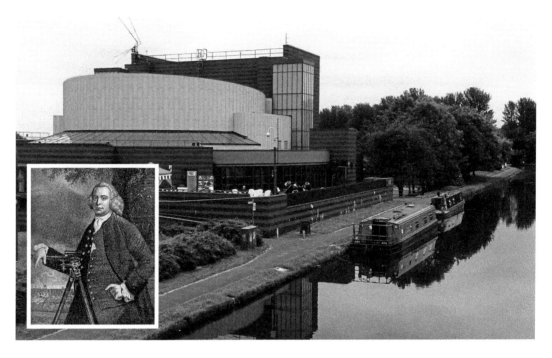

James Brindley

Brindley was born in 1716 at Tunstead near Buxton. Although he worked as a farm labourer, his future skills were already evident in his interest in making working models of water mills. At seventeen he was apprenticed to Abraham Bennett, a Macclesfield millwright. Here he gained experience in the construction of machinery, both for water and windmills. He was already showing his inventiveness. By 1759 he was surveying a canal route for Lord Gower and earlier still he had worked at Clifton to solve the problem of pumping water from Fletcher's colliery. It is evident then that the duke and his agent John Gilbert knew of James Brindley and his services were secured. From the middle of 1759, he had visited Worsley Hall a number of times and by the end of the year the length of canal from Middlewood had been cut. He went on to work on many successful canal ventures. In 1771, while surveying a new branch of the Trent and Mersey near Leek, he was drenched in a severe rainstorm. It had happened many times before, but he was unable to dry out properly at the inn at which he was staying, and caught a chill. He became seriously ill and returned to his home at Turnhurst, Staffordshire, where Erasmus Darwin attended him and discovered that he was suffering from diabetes. James Brindley died aged fifty-six in 1772. He was buried on 30 September, just nine days after the completion of his Birmingham Canal. Brindley's name is celebrated in many places along the canal. Here we see the Brindley Theatre and Arts Centre beside the canal in Runcorn.

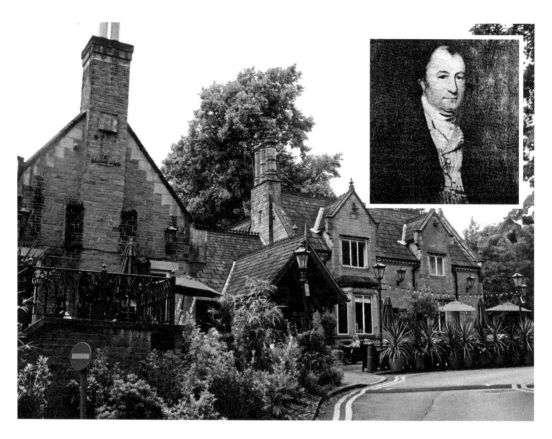

John Gilbert

He is often overlooked when telling the story of the Bridgewater Canal. He was the mine agent at Worsley and he helped to turn the duke's scheme into reality. He was the younger brother of Thomas Gilbert, the duke's chief land agent and legal advisor. He first worked for the duke in 1753 and resided at Worsley from 1759. It was Gilbert who solved the problem of a water supply for the canal. He resolved to build a slough to drain the mines at a lower level. This solved two problems – mine drainage and a water supply for the new canal. It was also his idea to build the slough large enough to allow flat low boats to pass down, carrying coal out of the canal. It was Gilbert who introduced James Brindley into the project. Despite the scheme's eventual success, Brindley and Gilbert do not seem to have got on very well together. They were both men of strong tempers and neither would tolerate the other's interference. Gilbert, being the duke's factotum, was accustomed to call Brindley's men from their work, which Brindley resented.

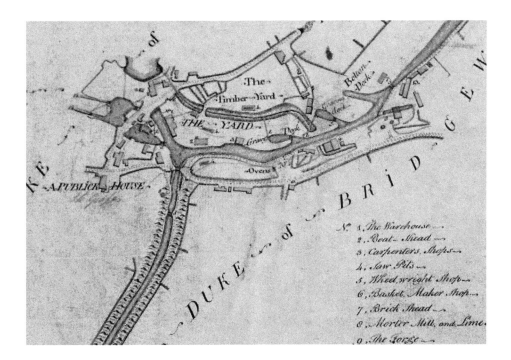

Foulkes Map Worsley, 1785

This is an extract of the Worsley Basin from the 'Maps and Survey of the Canal from Worsley to Manchester in Lancashire and from thence to the Tunnel at Preston and to Runcorn in Cheshire with Land adjoining being the property of His Grace the Duke of Bridgewater'. This manuscript map was drawn up shortly after the completion of the initial two phases of construction of the Bridgewater Canal. In this survey of the Worsley area, what is noticeable is the number of workshops already in place to service the needs of the canal. The graving dock is marked and the dry dock is still busy today.

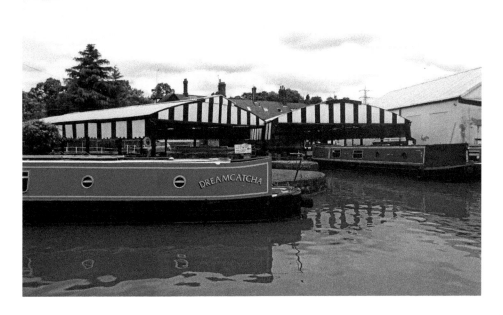

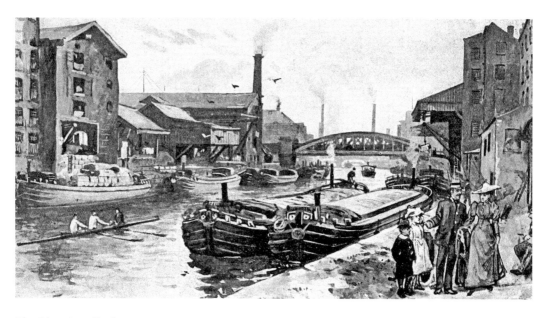

The River Irwell, 1890

As early as 1740, wharfs were built at Quay Street and traffic was passing through the Mersey and Irwell Navigation to Warrington. The navigation was always beset by the problems of the winding course of the river and its shallow depths. The duke was quick to see that his canal would be a successful venture and took action to avoid these problems. Tidmarsh's charming drawing shows the busy wharfs. The modern photo was taken from the Victoria and Albert Hotel in Water Street.

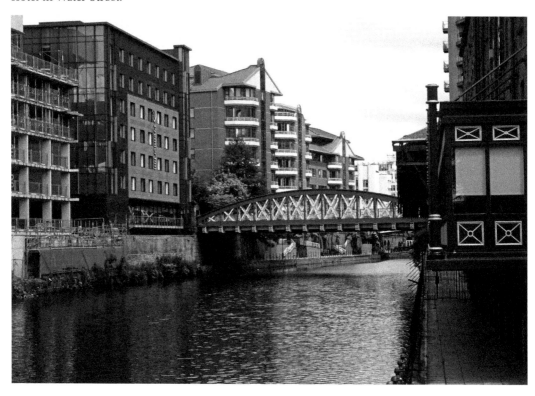

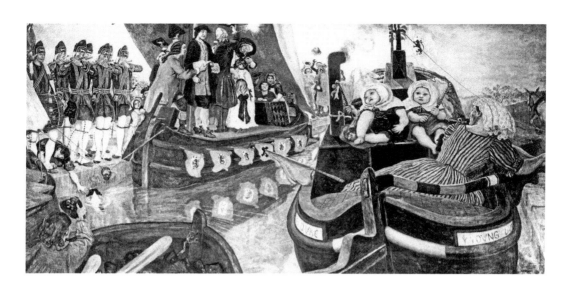

The Opening of the Bridgewater Canal, 1761

One of a number of murals commissioned for Manchester Town Hall, this one was by Ford Madox Brown, seen in the inset image. Completed in 1892, the painting was not well received. It depicts the ordinary workers on the canal, complete with babies safely tied on. The dignitaries behind are not featured well. According to Brown himself, James Brindley is pouring some brandy for the officiating Duke of Bridgewater, and pointing out that 'his Grace (who was not of a convivial turn) ... has omitted providing refreshments'. The band are all handsomely liveried, but here again the working class intrudes, with a boy reaching between their legs, trying to get his dog out of the water. The official opening was on Tuesday 17 July and here we have the account from the *Manchester Mercury*:

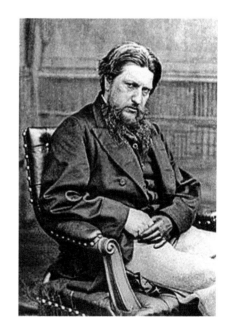

His Grace the Duke of Bridgewater with the Earl of Stamford and several other gentleman came to Barton to see the water turned into the canal over the River Irwell, which drew a large number of spectators and it is with pleasure that we can inform the public that the experience answered the sanguine expectations of everyone present. As soon as the water had risen to the level of the canal a large boat carrying upwards of 50 tons was towed along the new part of the canal over arches across the River Irwell, which were so firm, secure and compact that not a drop of water could be perceived.

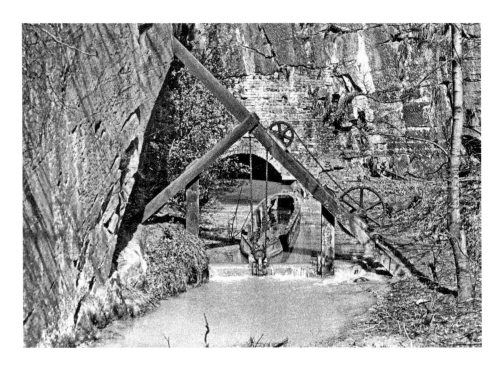

Underground Workings at Worsley

Small-scale coal mining had been carried on at Worsley since the Middle Ages, and had been further developed by Scroop Egerton. The coal was mostly sold at the pits. A small quantity was transported to Manchester by packhorse. The duke planned to increase the coal output and devise a means to transport it to Manchester. The most remarkable of the plans at Worsley was the underground canal system. Work started at the same time as the surface canal. Tunnels were driven north through the sandstone at Worsley Delph from the two entrances at Worsley basin.

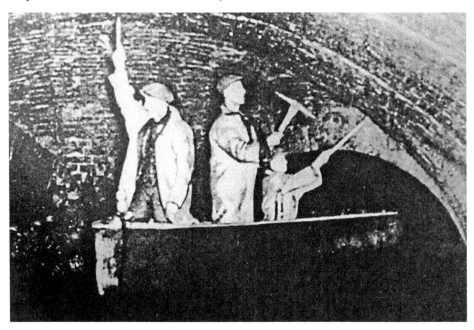

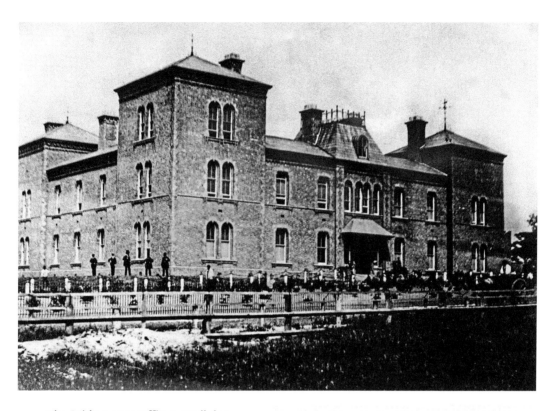

The Bridgewater Offices, Walkden
These were the old earl's offices, and stood on Bridgewater Road just before the swimming baths. Built in 1868, a clock was added in December 1900. Up to 1929 all three Bridgewater companies were based here. When Manchester Collieries took over in 1929, the decision was taken to move the estates offices back to Worsley. The company was sold to Manchester Collieries and nationalised in 1948. This brought to an end the link between coal and water. The map shows the extent of the underground canal system up to Morris Green.

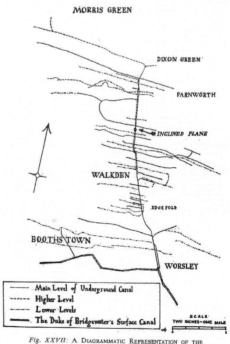

Fig. XXVII: A Diagrammatic Representation of the Underground Canal System.

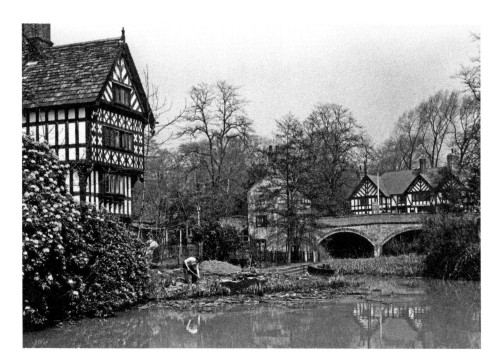

Worsley Packet House

Originally a group of houses built in 1760, the half-timbering was added around 1850 by the 1st Earl of Ellesmere. The canal carried passengers as well as cargo. You would have purchased your ticket for the 'packet boat' at the Packet House and boarded at the boat steps. The service began in 1769. By 1781 there were daily sailings, excluding Sundays, to Runcorn – a journey of eight hours. Another service ran from Manchester to Worsley in two and a half hours for 1s and 6d steerage.

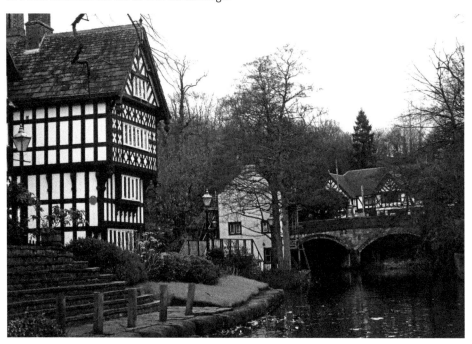

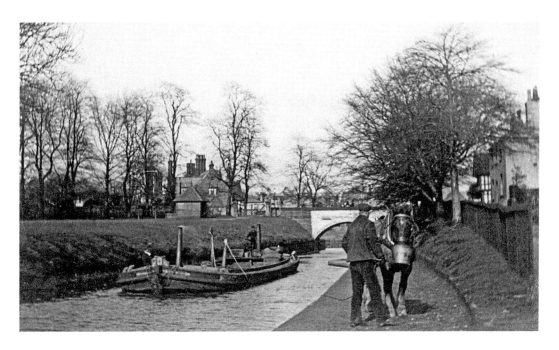

Worsley Towpath, 1905

A healthy horse was essential to the boatman, and great pride was taken in its welfare and grooming. Good food was crucial as a horse had to work all day and pull up to fifty tons. The horse would be fed while still moving. Once trained, the horse soon learnt where to stop at the lock and keep the boat travelling smoothly. Often the boatman had to buy his own horse and harness as well as food. Today, Worsley Bridge is very overgrown. The colour of the canal is a result of the mine workings nearby.

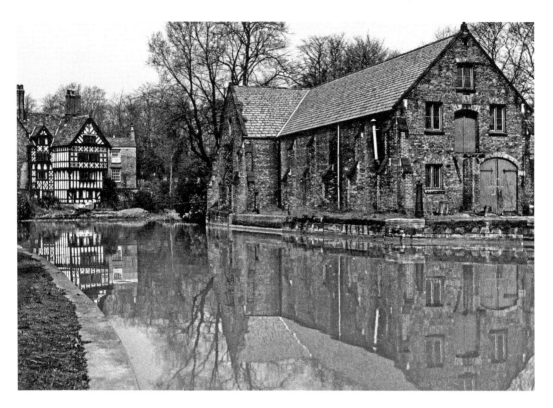

Worsley Oil Stores

The oil stores were built in 1852 as storage for the canal and the mine operations. The attractive building resembles a medieval tithe barn in some respects. In 1986 the building was converted into very desirable flats. The modern scene shows a very busy canal and the Packet House beyond.

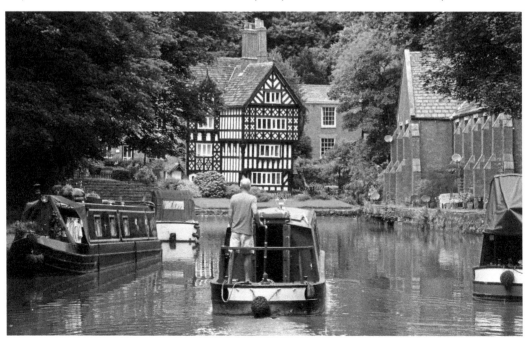

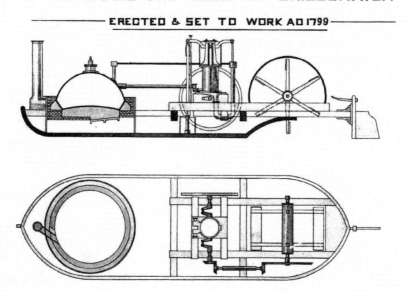

PLAN & SECTION OF A STEAM BOAT & ENGINE
FOR HIS GRACE THE DUKE OF BRIDGEWATER
ERECTED & SET TO WORK AD 1799

Steam Diagram, 1799

The duke was keen to try the possibilities of steam and here we see the early design believed to have been designed by Robert Fulton. Sherratt of Salford supplied her Newcomen-style engine – not the best type for a boat – but the Watt design was protected by patents, which fortunately expired in 1800. It was not a success – it went slowly, and the paddles, made sad work with the bottom of the canal, and also threw the water on the bank. Following the duke's death, the trustees refused to proceed with the experiment, and so the project fell through. Steam, of course, did later come to the canal and here we see a steam tug turning at Preston Brook Tunnel. Many of these were later converted to diesel at the Runcorn yard.

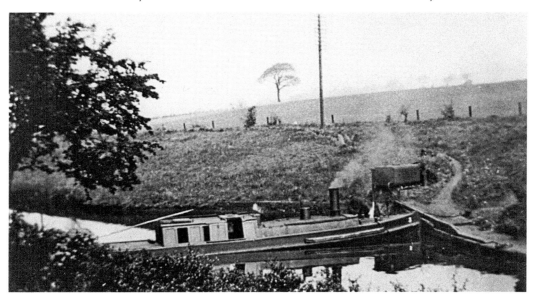

The Boat House

This fine boathouse was built to house the royal barge on the occasion of the visit of Queen Victoria in 1851. It was commissioned by the 1st Earl of Ellesmere and has a fine castellated entrance arch. The boathouse and the nearby footbridge are Grade II-listed buildings. The boathouse has been extended to become a private residence.

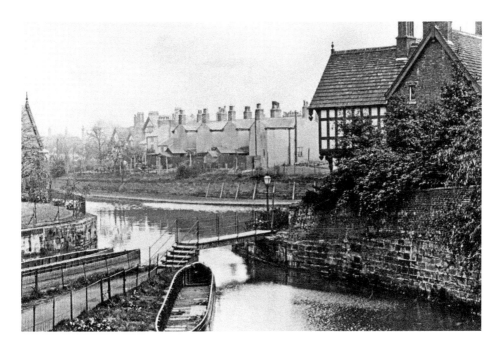

Worsley, 1906

This little bridge next to the Packet House in Worsley is known as the Alphabet Bridge. There were twenty-six planks and children from nearby St Mark's School used to practice the alphabet as they walked over it. The bridge crosses one of the ways into Worsley Delph, the old entrance to the underground series of coal mines that the canal system was built to serve.

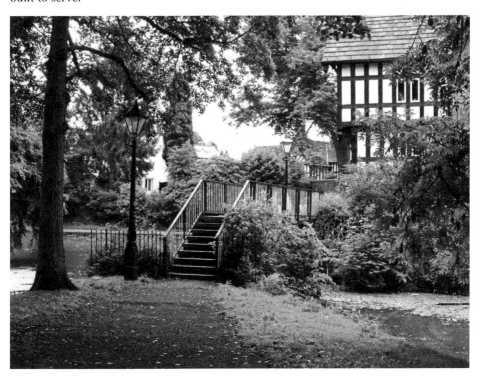

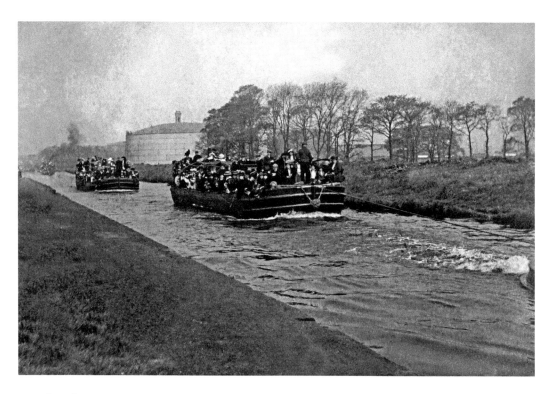

Worsley Pleasure Barge

In later years, the earl encouraged his rich landowner friends to take trips along the canal. Here we see affluent families enjoying a trip on the canal, although these barges do seem to be rather overloaded. They seem to be in convoy and the last one seems to be towing yet another barge. In the background are circular buildings, possibly grain stores. Today, a trip in the canal is undertaken in the luxury of the *Francis Egerton*, a restaurant boat operated by Bridgewater Cruises.

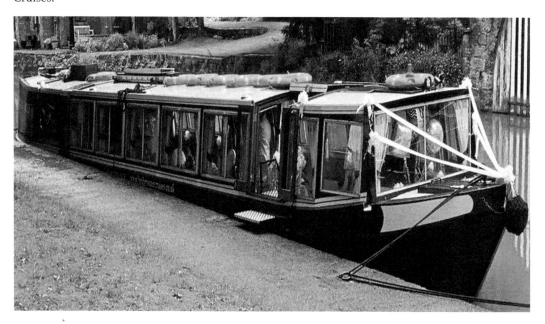

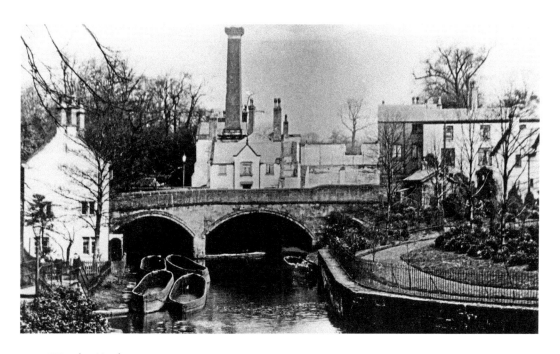

Worsley Yard, 1901

This view shows Worsley yard behind the bridge. It was demolished around 1902. It was a vast centre of an industrial activity when work began on both the surface canal and the navigable level. It included a boat-building yard, motor mill, timber yard, nailmakers, wheelwrights, basketmakers and a warehouse. It is still possible to see the imprints in the grass where railway sidings ran. Today, it is a fine village green. On the green you will find Worsley's only monument to Francis, 3rd Duke of Bridgewater – 'The Canal Duke'. This was constructed from the base of the works yard chimney.

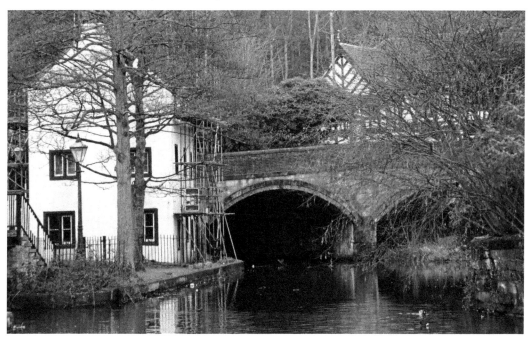

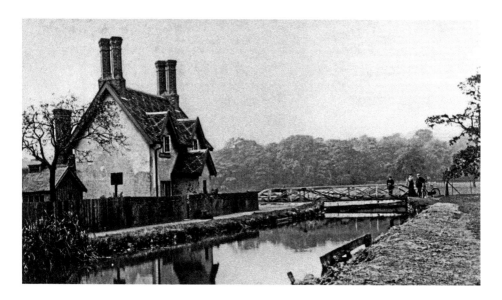

Worsley Swing Bridge

A lovely view of the swing bridge by the footpath to Worsley New Hall with Middle Wood in the background. The land to the south of the Bridgewater Canal was connected by a series of wooded drives or rides, which gave access to the northern area of the park. Around 1785, a second short canal called Moss Canal was built onto Chat Moss. It is shown at the bottom of the 1906 map. The grounds of Worsley Hall are now being developed as a Royal Horticultural Society Garden, which is due to open in 2019. It will bring the lost historic grounds at Worsley New Hall back to life.

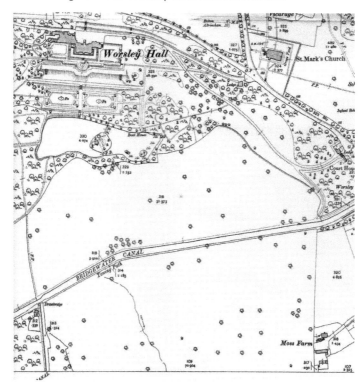

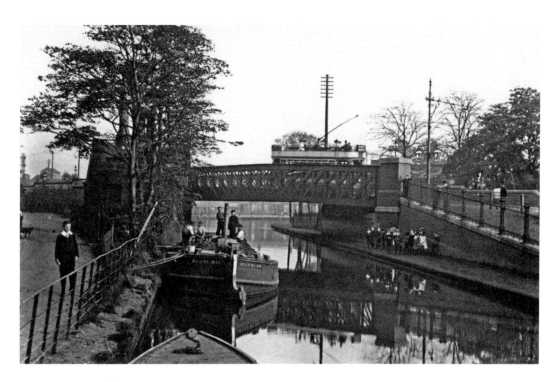

Monton Bridge, 1900

The first bridge was built over the Bridgewater Canal at Monton in the 1760s. When Queen Victoria visited Worsley, the bridge was adorned with flowers and evergreens. It was modernised around 1905, pictured here, to allow trams to cross the canal. Here we see one going over the bridge. This bridge replaced the old stone bridge. Today we see 'Waterside', formerly the Barge Inn and the fine folly – a lighthouse.

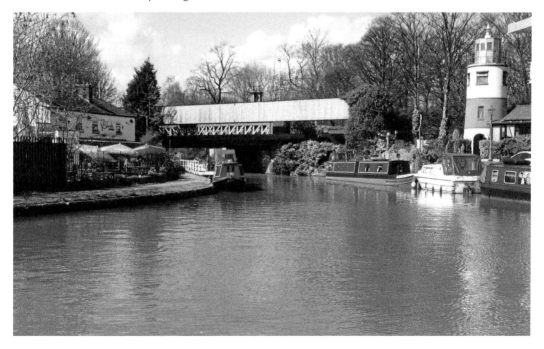

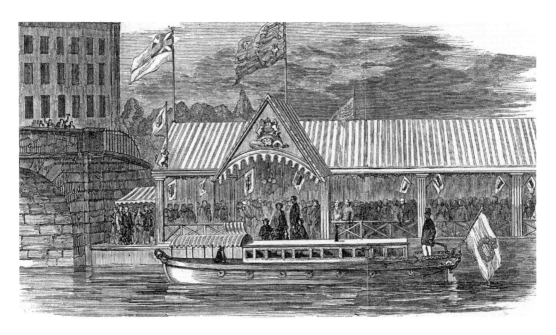

Queen Victoria's Arrival, Patricroft

The Royal Visit to Worsley in October 1851 was the first to the area for 150 years. The queen left Liverpool with Prince Albert and arrived by train at Patricroft Station. She wrote at the time, 'We walked through a covered and ornamented corridor to the boat. It was a very elegant barge drawn by four horses. The old Duke of Wellington and Captain Egerton came into it with us.' The horses had been rehearsed but unfortunately one reared when he heard the cheering crowds and fell into the canal. The view today is sadly rather less romantic.

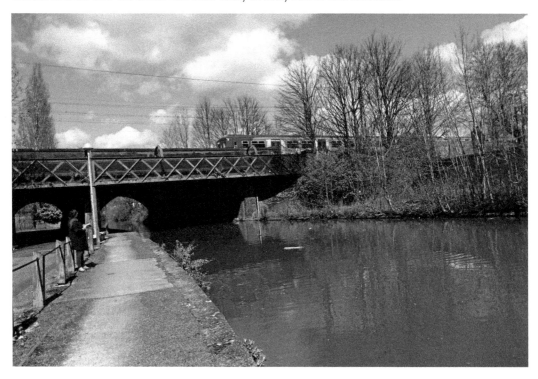

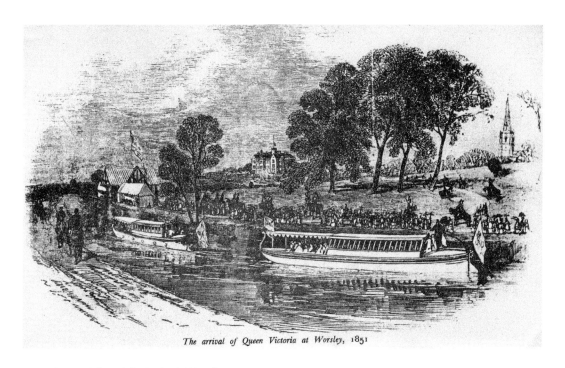

The arrival of Queen Victoria at Worsley, 1851

Queen Victoria's Arrival, Worsley

The queen travelled along the Bridgewater Canal to the New Hall. In preparation for her arrival, the water in the canal was dyed blue. The Earl of Ellesmere also commissioned a royal barge and built a landing stage on the banks. As the boat glided along the canal, the banks were lined with cheering people. On arriving at the hall she wrote, 'The evening was so wet one could not see beyond the windows.' The next day, the queen visited Peel Park. This postcard imagines the massive crowds who welcomed the queen. A grand triumphal arch was erected at the entrance of the park and over 80,000 Sunday schoolchildren greeted her. The children arrived around 6 a.m. and must have waited patiently as the queen did not arrive until 11 a.m.

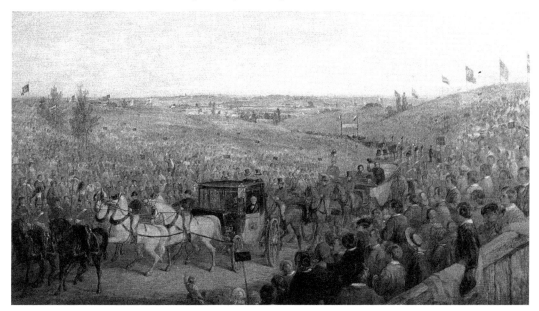

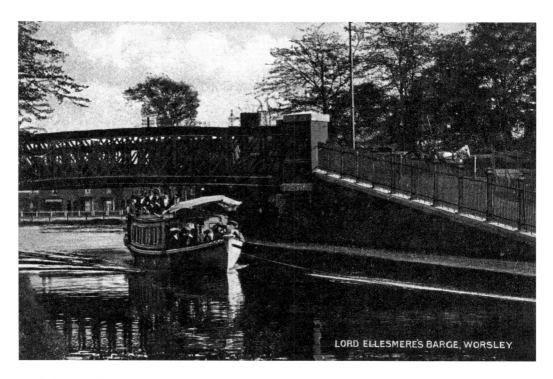

LORD ELLESMERE'S BARGE, WORSLEY.

Lord Ellesmere's Barge, Monton

Here we see Lord Ellesmere's barge, which had been specially commissioned for the visit of Queen Victoria. The outriders wore fine livery and were responsible for towing the barge. *The Times* described the barge as 'elegant and commodious. Forty seven feet in length and the saloon lined in crimson silk velvet.' Is this a ladies outing? It was later converted to diesel power and was in use until 1948.

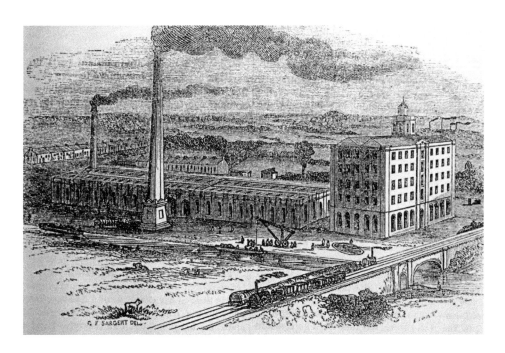

Foundry, Patricroft, 1843

A fine illustration of this historic building, which was established in 1836 by James Nasmith; it was also where he invented the steam hammer. He became quite an eminent man of the area and he was invited to the Worsley New Hall in 1851 to meet the queen during the first evening of her visit to Worsley. The foundry was strategically positioned by the railway and the canal. By 1838, he had the capacity to begin accepting orders for steam locomotive engines. During the First World War, the factory was mainly engaged in munitions work. The later photo shows the canal and a horse-drawn barge.

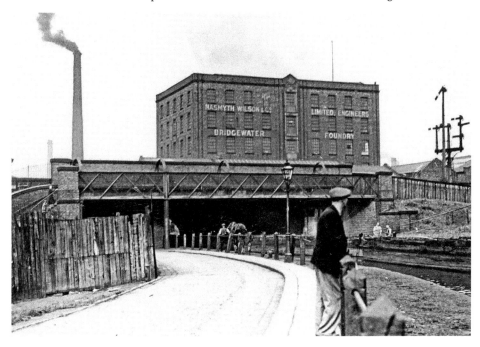

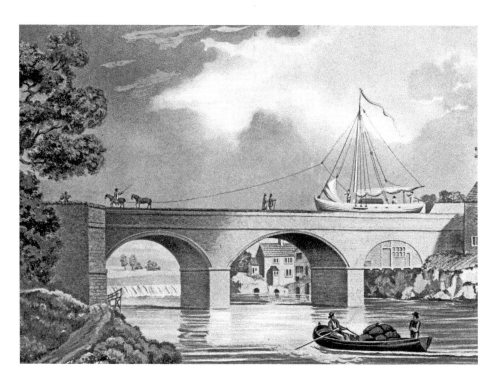

Barton Aqueduct, 1795

A rather romantic image of the aqueduct. The appointment of James Brindley was a stroke of genius. The duke ignored his lack of formal education and rough speech. When Brindley first suggested an aqueduct to solve the problem of crossing the much lower River Irwell, the enterprise was scorned. However, the duke backed Brindley and, as we know, it worked well. When Queen Victoria visited Worsley, she refused to cross the aqueduct, saying that would be more like flying than sailing.

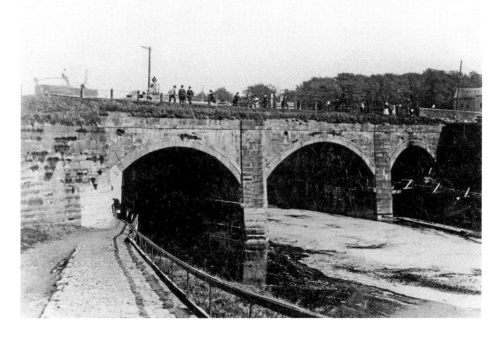

Barton Aqueduct, 1891

One of the Manchester Ship Canal's earliest requirements was to replace Brindley's stone aqueduct at Barton with the present steel swing aqueduct. This would carry the Bridgewater Canal over the Ship Canal, as famous today as its predecessor was in 1761. The aqueduct pivots on an island built in the middle, controlled hydraulically from the tower. The stone aqueduct has been demolished but a very similar structure can still be seen in Sale at the Hawthorn Lane Aqueduct.

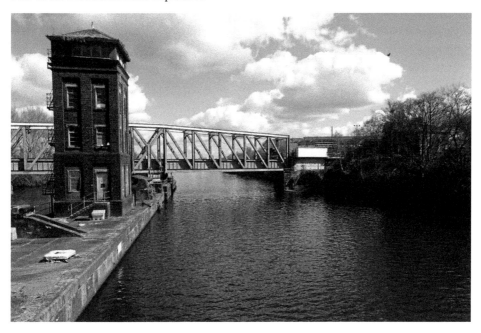

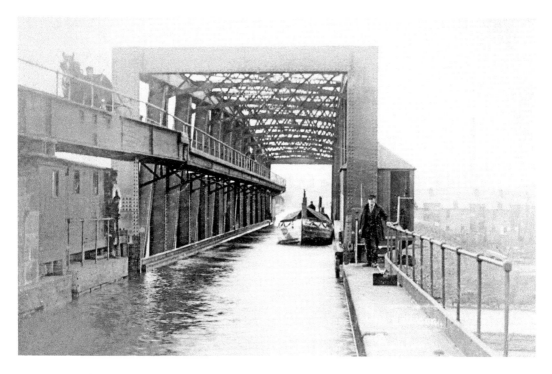

Barton Aqueduct, 1894
The steel swing bridge and a view along the water showing a horse above on the towing path. The horse would wear blinkers so that it would not be distracted by the water below. The swinging action allows large vessels using the ship canal to pass underneath and smaller narrowboats to cross over the top. The aqueduct is the first and only swing aqueduct in the world. The towpath above has now been removed.

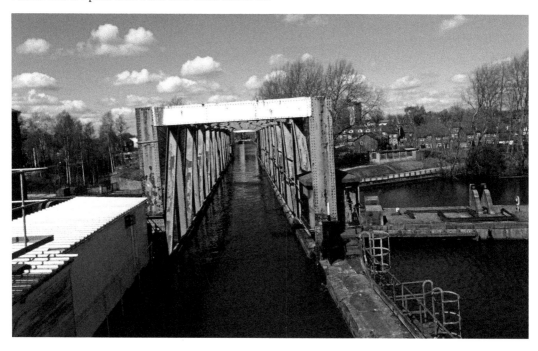

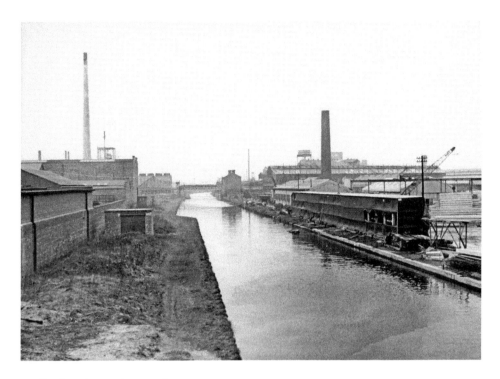

Trafford Park, Mosley Road

Trafford Park was part of the ancestral home of the De Trafford family, originally a very beautiful park and farmland extending over 1,183 acres. Like many landowners, they did not welcome the Bridgewater Canal. Sir Humphrey De Trafford was further angered by the development of the MSC and sold the land to E. T. Hooley to create a pleasure park. However, Hooley could not resist the temptation to make a quick profit and sold the land to the Trafford Park Estates Company. Trafford Park quickly became the most famous industrial estate in the world.

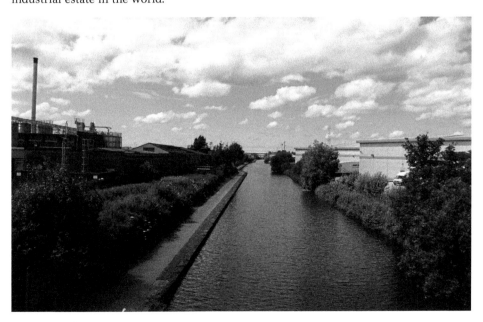

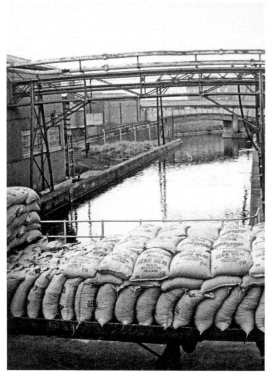

Kellogg's Trafford Park
Kellogg's opened their huge factory
in 1938 and quickly became one of
the largest local employers. They now
employ over 2,000 people in Greater
Manchester. The site by the Bridgewater
was ideal for bringing the grain along
the canal. The Bridgewater Canal
enjoyed a 'working life' of over 200
years, commercial traffic only ceasing in
1974. It is appropriate that the last cargo
consisted of four barges of maize carried
from Salford Docks to Kellogg's in
Trafford Park. This was celebrated with
a flotilla of barges festooned with flags –
the end of an era.

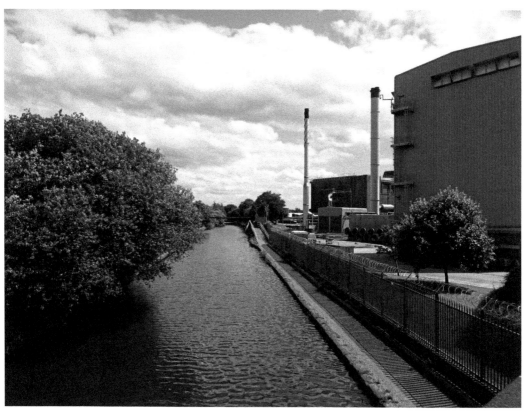

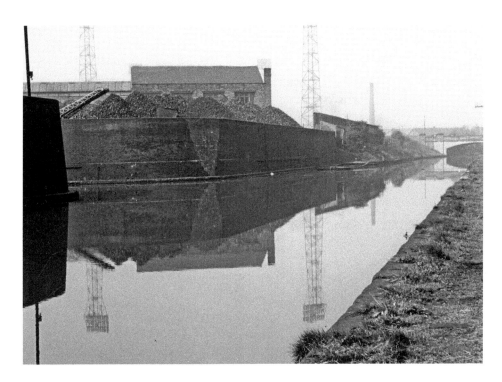

Warwick Road Bridge

The canal is pictured here with Old Trafford football ground in the background and a coal yard in the foreground. Old Trafford has been Manchester United's home ground since 1910. In 1936, as part of a £35,000 refurbishment, an 80-yard-long roof was added to the United Road stand. The stadium suffered German bombing during the war because of its proximity to Trafford Park. The ground has been transformed since then, including the addition of extra tiers to the north, west and east stands, almost returning the stadium to its original capacity of 80,000. It is the largest club stadium of any football team in the United Kingdom and now justifies its nickname as the 'Theatre of Dreams'.

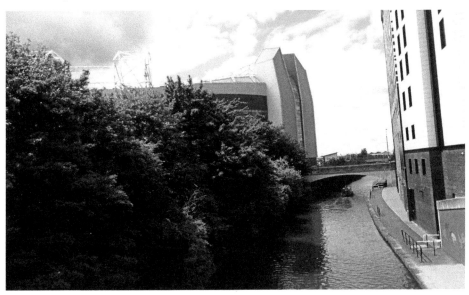

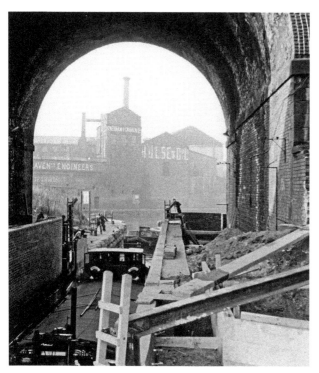

Hulme Locks

This branch of the canal was built to provide a direct waterway between the Mersey and Irwell Navigation and the Bridgewater Canal. The canal opened in 1838. This photo shows reconstruction in 1962. As both of its locks remain closed, the canal is now overgrown. There are two lock chambers still in existence. The upper lock was certainly working in the 1930s, but with a much shallower drop than the lower lock. The sides of the intermediate basin have been built up since then, and the lower lock made full height.

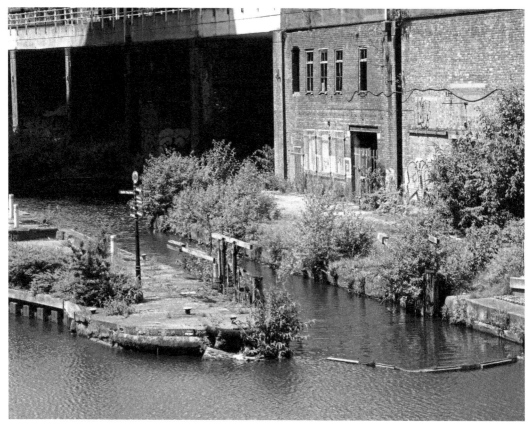

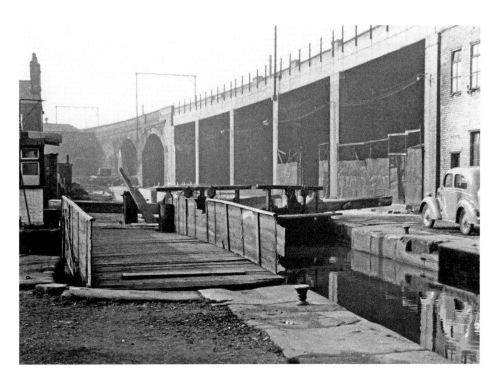

Hulme Locks

A reconstruction of the old swing bridge. Hulme Locks was not the original connection with the River Irwell, which was 'The Gut'. Hulme Locks were replaced in 1996 with the construction of Pomona Lock a short distance downstream. The scene is now still dominated by the railway but the new apartment blocks are providing fine homes near to the city centre.

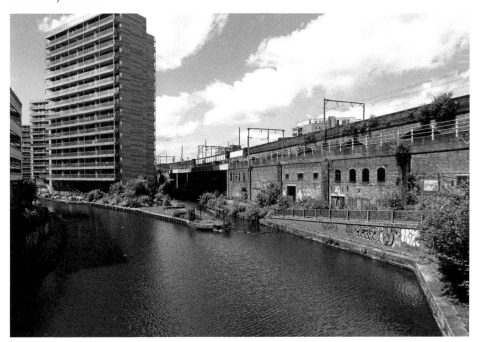

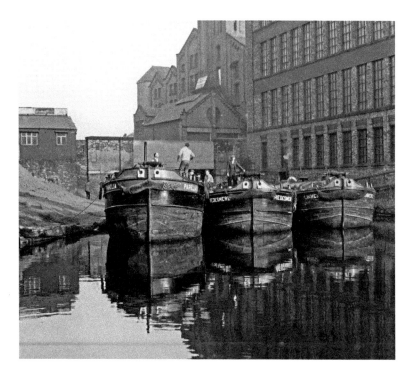

Large Barges, Hulme Locks

Parelia was ordered from Yarwood's around 1950. *Redesmere* and *Linmere* were part of the Mere fleet. They were purchased around 1947 using war remuneration money. Bridgewater Transport, part of Manchester Ship Canal Company, ordered three new diesel tugs and six steel dumb barges, known as 'Mere' barges. This new fleet was used extensively and the older tugs and canal flats were phased out. They worked this stretch of the waterways from 1952 until their last delivery to Kellogg's in March 1974. Unfortunately, *Parelia* was scrapped shortly after trade ceased. The majority of these barges went to Nigeria to continue as towed lighters and may still be working there.

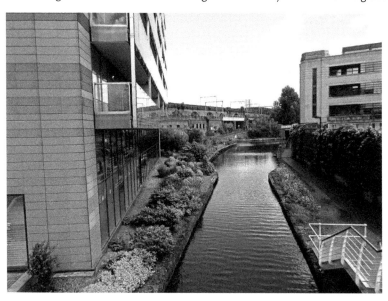

Divers at Hulme Locks

A trained diver is a vital part of the canal maintenance team, carrying out underwater inspection and repair work as required. It is dark and difficult work and not for the faint-hearted. In the image on the right, we see Jack Simpson, his linesman and his second diver. Jack was the diver for the mechanical department at Mode Wheel Locks. His job was to keep the locks, including Hulme Locks, in working order. The lower image from 2006 shows Frank Brown with his colleagues at Mode Wheel Locks, one week before the team finished employment at the MSC. They are using the AH2 (Air Helmet 2), built by General Aquadyne. This type of helmet is preferred over demand-flow helmets for heavy work when the diver is breathing hard or for cold or contaminated water. The inset image shows Frank's father Bill Brown (bottom left) alongside his uncle, Les Brown. After leaving the Royal Navy, they entered MSC diving service, gaining such a good reputation that it used to be said, 'If you want the job done, call for the Brown Brothers.'

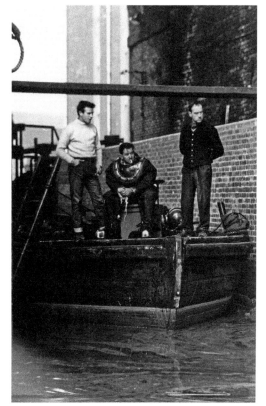

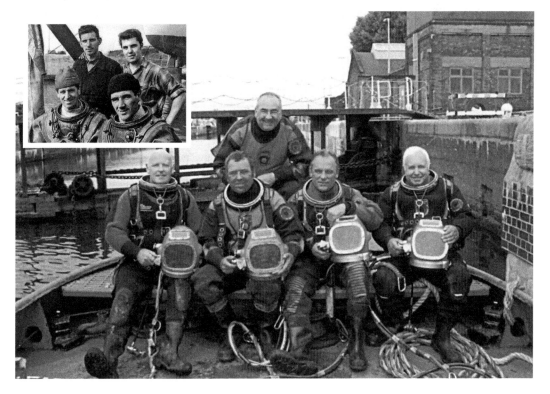

Hulme Locks
Beyond is the distinctive Sunblest Kingpin flour mill on Worsley Street. It was built in 1896, complete with an integral canal basin and loading facilities. The mill was still taking in grain direct from the barges on the canal in the 1960s. This area of the canal is now dominated by modern apartments, the Timber Wharf.

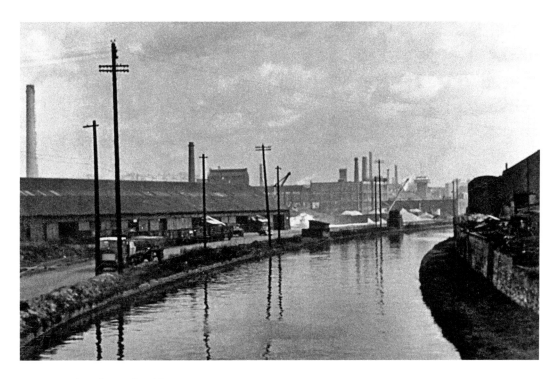

Cornbrook Road Bridge

By the end of 1761 the canal had reached Cornbrook and in 1765 it reached Dolefield (Castlefield). It was noted in 1763 that 'here at Cornebrook the duke's agents have made a wharf and are selling coal at threepence halfpenny per basket and next summer they intend to land them in this town'. This view looks down the canal towards Hulme Hall Bridge and Hulme Locks. It shows how busy the wharfs were, even in 1961. The modern shot looks towards Throstle Nest Bridge and Pomona.

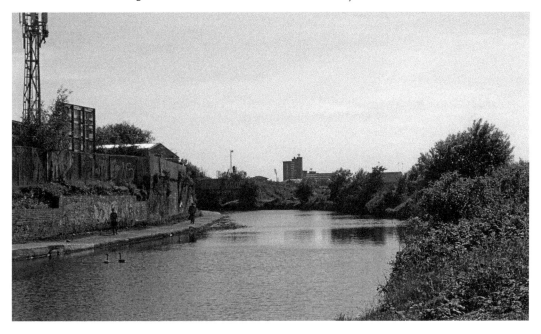

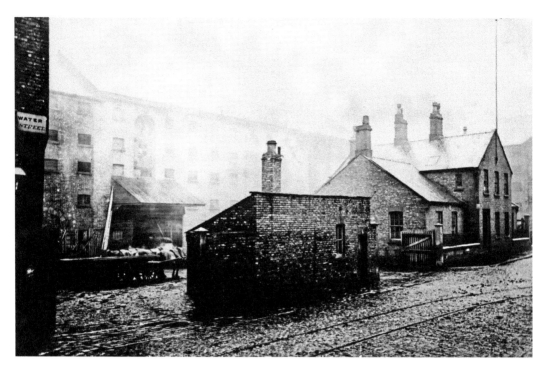

Bridgewater Warehouse, Water Street, 1870

Situated on the River Irwell so that 250-ton barges can come alongside, Water Street used to contain row upon row of warehouses, including the Victoria & Albert, the New Botany and many more. Many of them had livery stables that catered for the busy canal and the River Irwell. The Victoria & Albert has now been converted into a fine hotel.

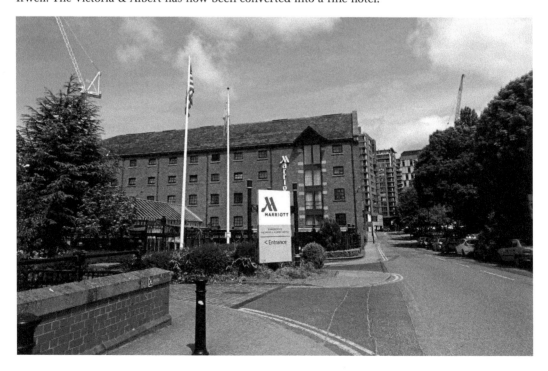

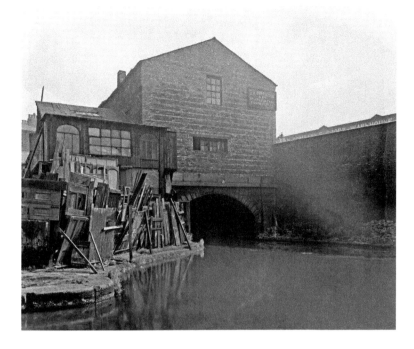

Junction Canal, Water Street

This is a remnant of the former Manchester and Salford Junction Canal. The canal once started at the Irwell near Water Street and passed beneath Deansgate and the Midland Railway Goods Yard, and finally below the former Central Station until re-emerging beyond Lower Mosley Street in the vicinity of the Bridgewater Hall. The canal opened in 1839 to compete with the Bridgewater Terminus. This provided an alternative route from the Rochdale Canal to the River Irwell, and cargoes from either direction could navigate onto the Irwell using the junction canal or Hulme Locks. The locks to the River Irwell can still be seen today near the hotel.

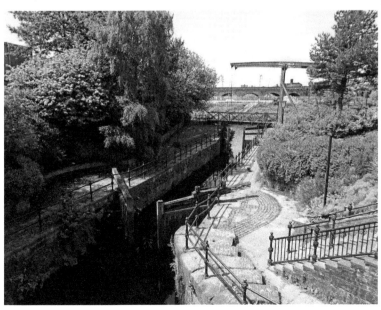

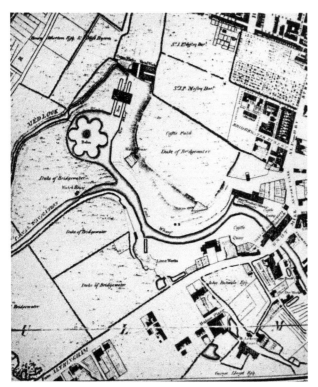

Green's Map, 1794

The map shows the basin and although by this time the duke had been able to purchase plots of land, this had not been easy. The manor of Hulme was purchased for £9,000 along with a corn mill and kiln at Knott Mill. The duke's finances were becoming strained and he was forced to mortgage the Hulme Hall property to its former owner for £4,500. In 1783, he purchased further properties from Sir John Parker Mosley and Oswald Mosley for £2,240. Knott Mill can be seen on the map (bottom right). Today, we see the landscaping on this part of the canal and Grocer's warehouse on the left.

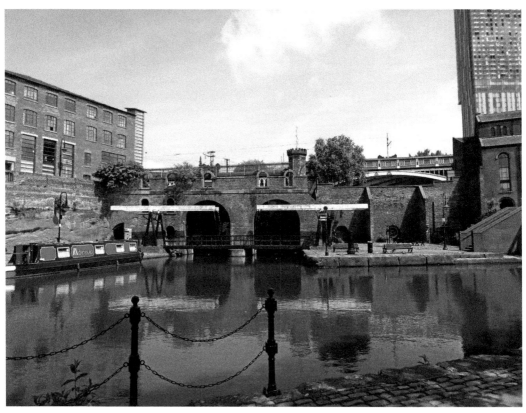

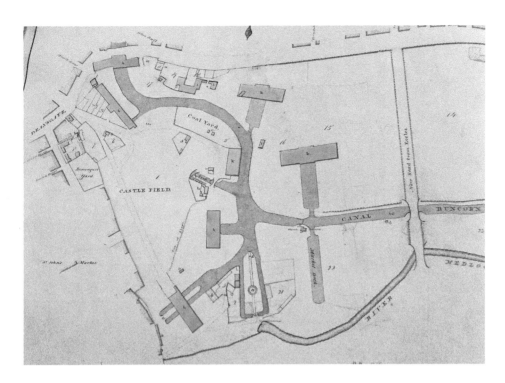

Castlefield, 1821

This is a later map produced by W. Stott. It shows how much the basin area has been developed with the coming of the Bridgewater Canal. The tonnage office is shown at 'b', the lockkeeper's house is at 'c' and 'k' shows the many warehouses. The River Medlock is shown at the bottom, flowing towards the River Irwell. The basin now looks very different today.

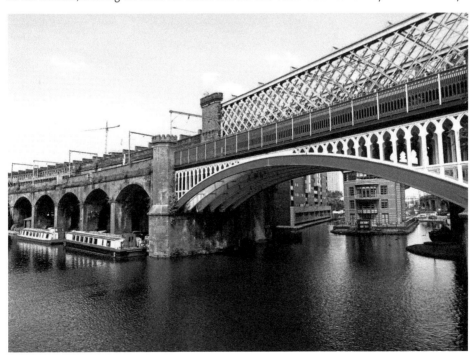

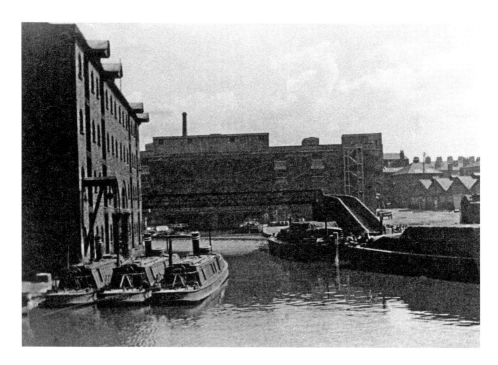

Castlefield Tug Harbour, 1939

The man behind the introduction of steam tugs was Edward Leader Williams. In 1856, he was chief engineer for the development of the navigable northern section of the River Weaver in Cheshire. He began to specialise in canal construction and in 1865 produced plans for enlarging the Weston Canal. On 1 September 1872, he became general manager of the Bridgewater Navigation Co. In 1872, a number of steam tugs were purchased. They were 60 feet in length and by 1881 there were twenty-six in regular use on the canal until the 1920s. Some were later converted to diesel and went on to be used until the 1950s.

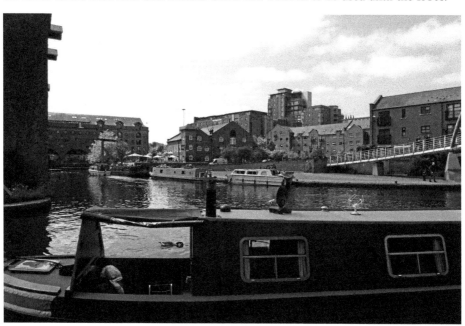

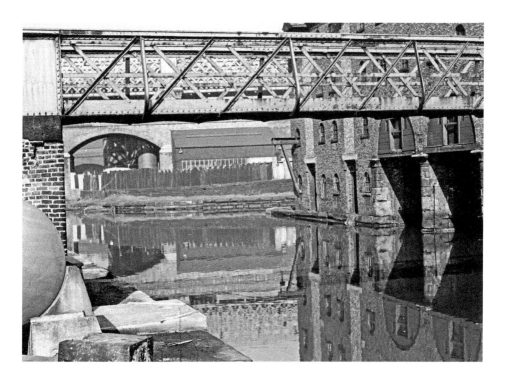

Merchants Warehouse, 1961

The warehouse was completed in 1827. It is an architectural triumph and is the oldest surviving warehouse on the canal. The warehouse takes its name from the main tenant, the Merchants Company. It was destroyed by fire in 1829 but rebuilt in 1830. Boats would enter through the arches and hoists would load and offload goods. It has now been transformed into fine offices.

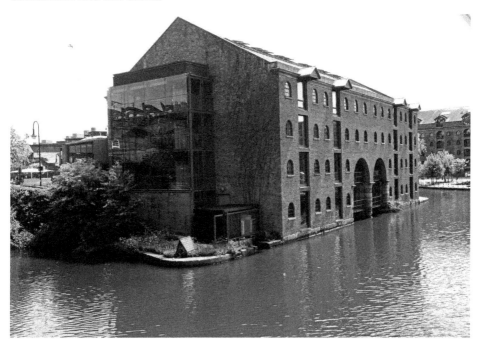

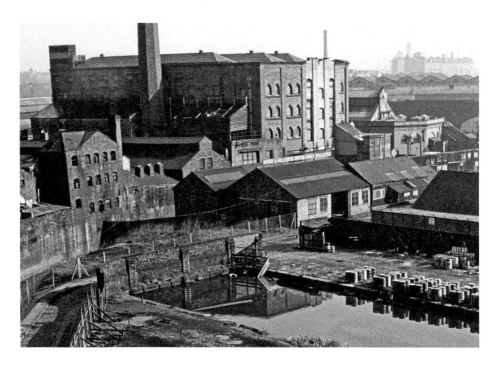

Potato Wharf, 1961

A high view over one of the many wharfs, built to handle the fast-growing canal trade. From the title it seems obvious what the main trade was, but maps and photos also show that timber was a major trade in this area. Halfway along is an overflow weir that takes excess water from the canal and drains it into the River Medlock (still in its tunnel). This weir was originally known as the Cloverleaf Weir due to its shape. It was originally much larger than today but, over the years, it has been reduced in size to what you can see today.

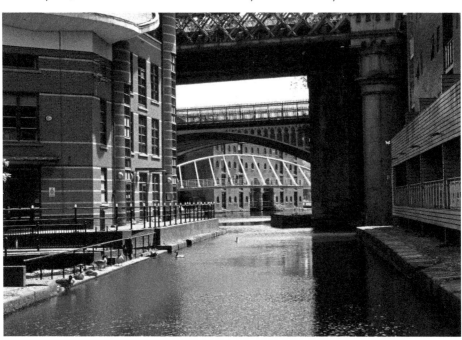

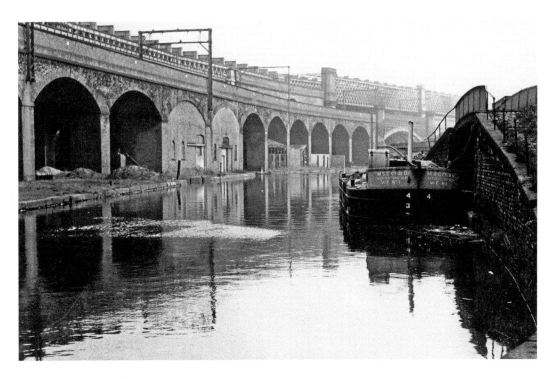

Railway Canal, 1967
The railway viaduct dominates the canal here as it runs into the old Central Station. Central Station was built in 1880, and is now Manchester Central Convention Centre. Castlefield is as conspicuous by its viaducts as it is by its canals – they have become an indelible part of the landscape, valued and treasured as part of Manchester's industrial heritage. We can just see the forty-seven-storey Beetham Tower on the right of the modern photo.

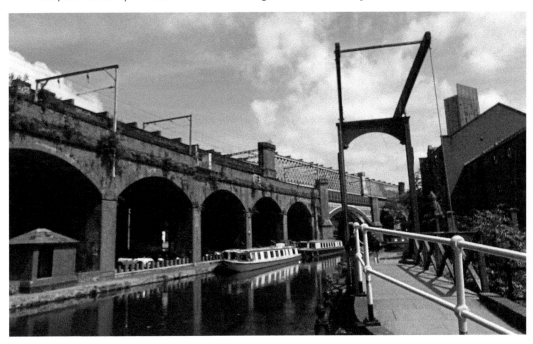

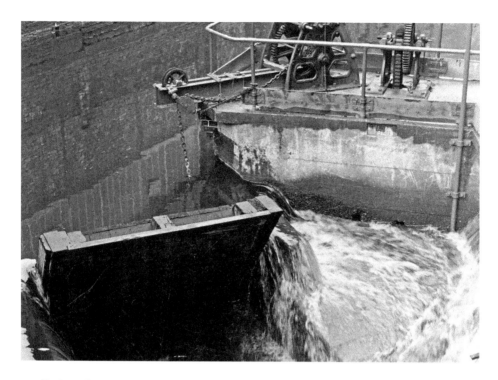

Medlock Weir, 1964

The main water supply to the canal was the River Medlock. The Medlock runs into the Bridgewater Canal in Knott Mill near Deansgate. A tippler weir sends excess water down into a tunnel that runs beneath the Castlefield canal basin. The modern photo shows the modern flats at Knott Mill and the water flowing beneath.

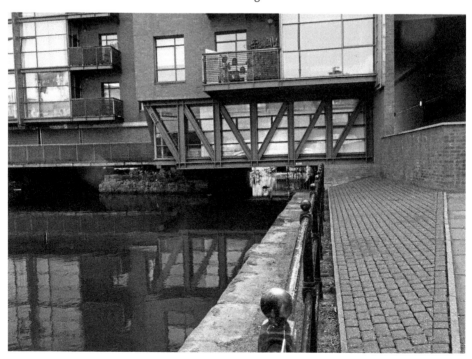

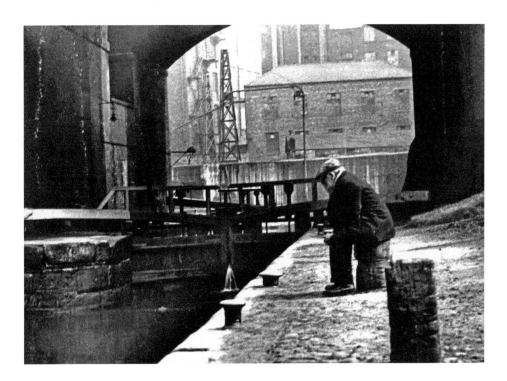

River Medlock

The river rises in the hills near Oldham. When James Brindley was building the canal he used the river to supply the water needed for the canal. In the latter part of the eighteenth century, the river was navigable at least between Deansgate and the site of India House on Whitworth Street. At India House was the entrance to a tunnel used to carry coal to a wharf at Store Street by Piccadilly station. The tunnel mouth is still visible. The tunnel was rendered obsolete by the silting of the river and the construction of the Rochdale Canal. The modern picture shows the river emerging from Potato Wharf to join the River Irwell.

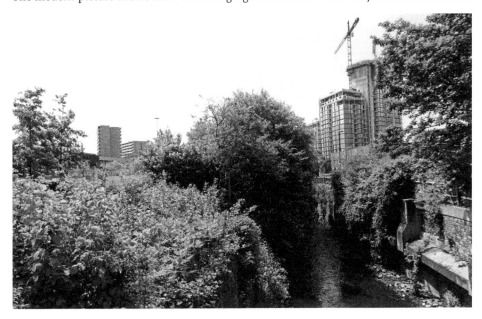

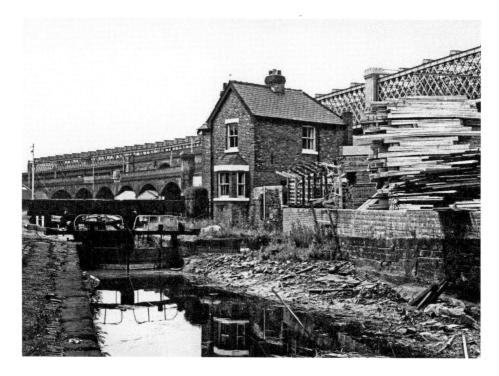

Rochdale Canal Junction, Lock Keeper's Cottage

It is at this point that the Bridgewater Canal meets the Rochdale Canal at Dukes Lock No. 92. The Rochdale then flows along Canal Street and on onwards to Sowerby Bridge where it joins with the Calder and Hebble Navigation. It was in Rochdale where the call was made to link a canal into Manchester but at first the Duke of Bridgewater refused to allow the proposed canal to join onto the Bridgewater Canal, meaning the canal would terminate at Piccadilly. In 1792 the Rochdale Canal Bill failed. The canal eventually opened through to Manchester in 1804.

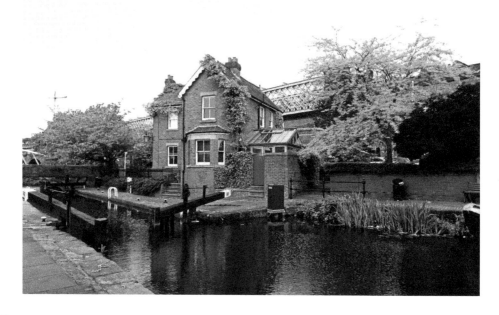

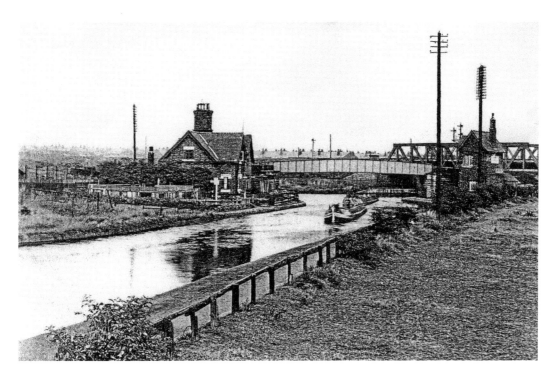

Stretford Waters Meeting

Here is the junction of the Bridgewater main line and the Leigh branch. At the junction, the canal flows left through to Castlefield and right to Altrincham and beyond. It was here that British Westinghouse Electric Company, later Metrovicks, built a factory. Before the canal could be built to Manchester, the intention was to unload coal at Longford Bridge and transport the coal by carriage. The two barges are heading down the Leigh branch.

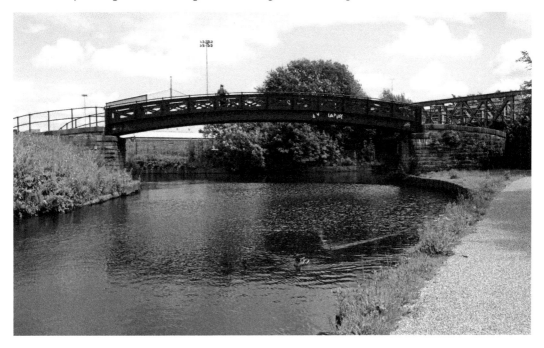

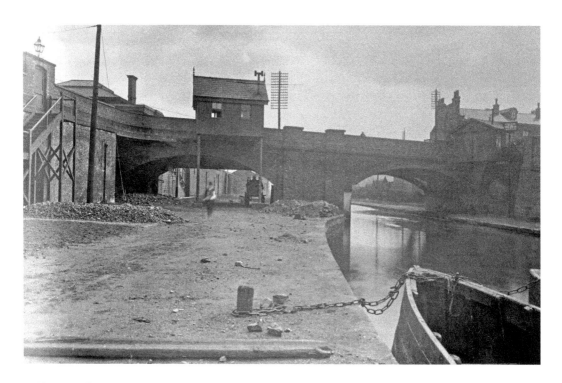

Bridge at Sale, 1903

West of the Mersey, Brindley faced the problem of the carrying of the canal over the Sale Moor Moss. Many thought this an altogether impracticable thing – not only did the hollow trunk of earth in which the canal lay need to be made watertight, but to preserve the level of the water it must necessarily be raised considerably above the level of the moor. Brindley had to use all his skills to overcome these difficulties. The canal is still busy here and beyond the bridge is the popular pub, the King's Ransom.

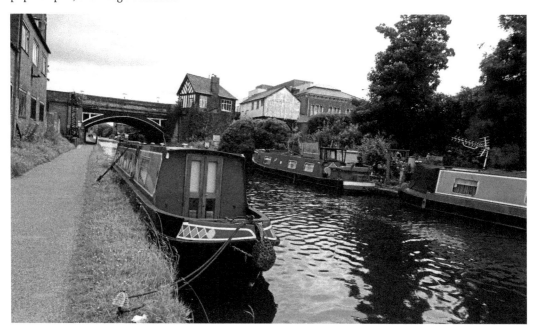

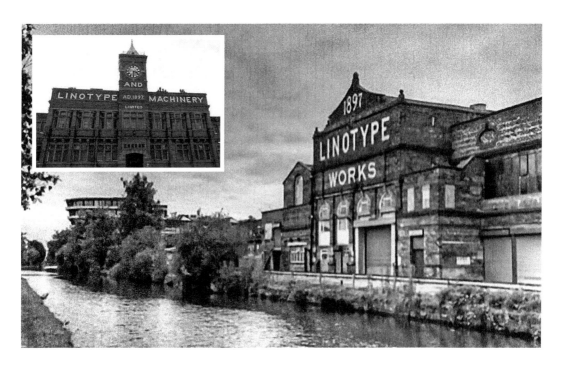

Altrincham Linotype

The Broadheath Industrial Estate predated the more famous Trafford Park by ten years. It was an excellent site on a flat heath beside the Bridgewater Canal. The first engineering factory was opened in 1884 and, at its peak, Broadheath employed over 10,000 people. Lynotype's new printing machine cut down on labour and saved space. It was also much faster than other machines and thus enabled newspapers and periodicals to increase production. Of course the position of the new factory was ideal for transporting raw materials and the heavy finished goods. The fine building still stands today but life by the canal near Broadheath Bridge is much quieter.

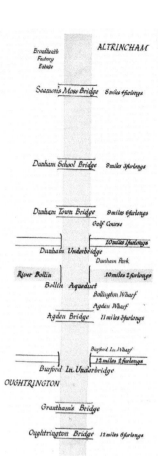

Broadheath Factory Estate

ALTRINCHAM

Seamons Moss Bridge — 8 miles 4 furlongs

Dunham School Bridge — 9 miles 3 furlongs

Dunham Town Bridge — 9 miles 6 furlongs
Golf Course

10 miles 1 furlongs
Dunham Underbridge
Dunham Park

River Bollin — 10 miles 2 furlongs
Bollin Aqueduct
Bollington Wharf
Agden Wharf
Agden Bridge — 11 miles 3 furlongs

Burford In. Wharf
12 miles 2 furlongs
Burford In. Underbridge
OUGHTRINGTON

Grantham's Bridge

Oughtrington Bridge — 12 miles 6 furlongs

Dunham

This diagram shows the canal from Seamon's Moss Bridge to Oughtrington Bridge. At Dunham Town Bridge, Brindley had a further problem – he needed to pump the water from the foundations. He erected a steam engine called a sawney and the bridge was known locally as Sawney's Bridge. The foundations of the underbridge were popularly supposed to be set on quicksand. A tall poplar tree stood at Dunham Banks, on which a board was nailed showing the height of the canal level. For a long time after, the local people called the place the 'Duke's Folly', the name given while his scheme was still believed to be impracticable.

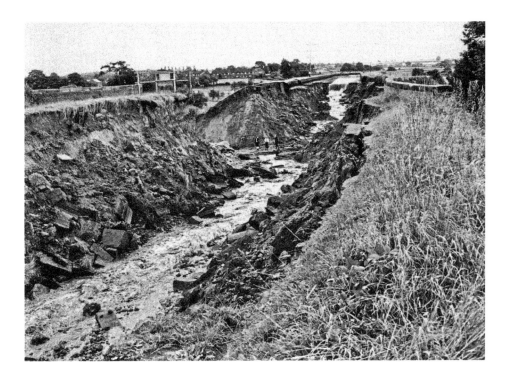

Dunham Breach

In 1971, the Altrincham police received a report of a leak of the Bridgewater Canal near Bollin Aqueduct, where the canal crosses over the River Bollin on an embankment. The canal gushed into the river below, causing a gorge in the embankment. Stop logs were positioned to stop the loss of water. Despite this, the water levels in the canal in Manchester fell by 14 inches. The cost of repair was £250,000 and the canal was saved by the formation of the Bridgewater Canal Trust. The Bollin is flowing quietly under the aqueduct today.

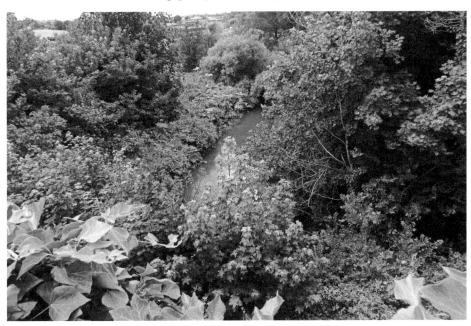

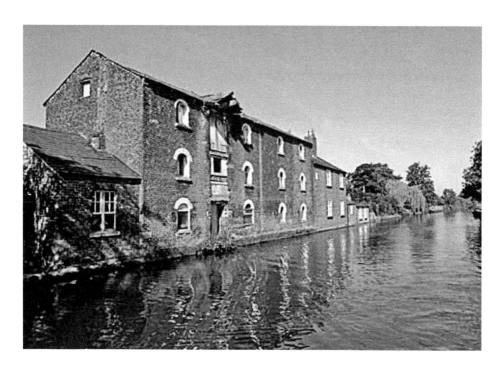

Horse Hospital, Agden

This canal-side building close to Agden Wharf was reputedly used as a horse hospital in the days when canal barges were towed by horses. The building still looks the same today and is crying out to be restored. However, in 2013 when the government announced the route for phase two of the proposed HS2 high-speed railway line from Birmingham to Manchester and Leeds, it was discovered that it would cross the Bridgewater Canal at Agden, exactly on Lymm Cruising Club's moorings. So this peaceful spot might be changed forever.

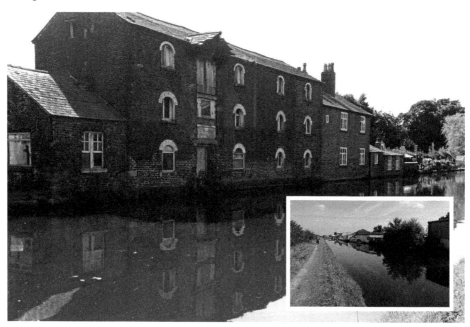

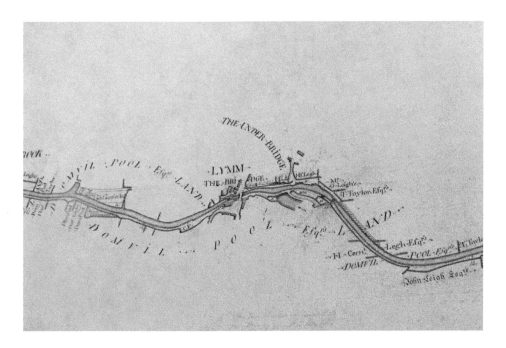

Foulkes Map Lymm, 1785

This map shows the many owners of the land whose lands the canal would run through. Often the duke had to pay dearly for the land purchased under the compulsory powers of his Act. Near Lymm, the canal passed through a little bit of garden belonging to a poor man's cottage, the only produce growing upon the ground being a pear tree. For this the duke had to pay 30 guineas and it was thought a very extravagant price at that time. We now see a view of a happy family enjoying cruising the canal passing towards Lymm Bridge.

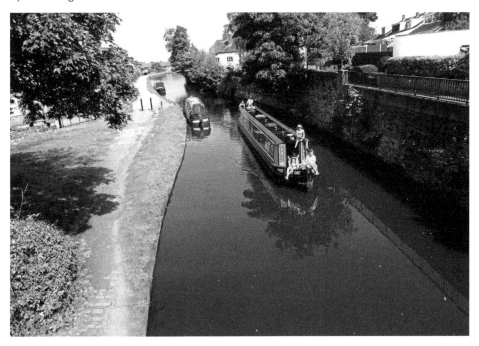

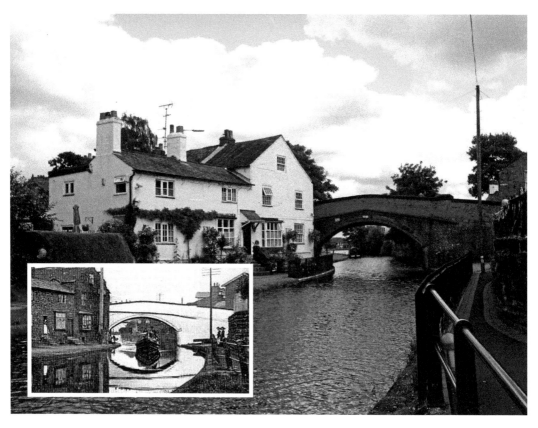

The *Duchess Countess* at Lymm Bridge, 1927

A familiar craft on the Bridgewater was the passenger or 'fly' boats that plied the length of the canal daily. One such craft was the *Duchess Countess,* which was built in 1871. These boats were given priority over other canal traffic and featured a knife on the bow to sever the towlines of any boats getting in the way. As well as conveying passengers, they also carried perishable goods and even cattle. The *Duchess Countess* was the last remaining example of these boats. She ended her days on the banks of the Llangollen Canal where she was broken up in 1960. There is a restoration society dedicated to constructing a replica of this historic boat. The bridge at Lymm is still an attractive spot and remains busy with boat traffic.

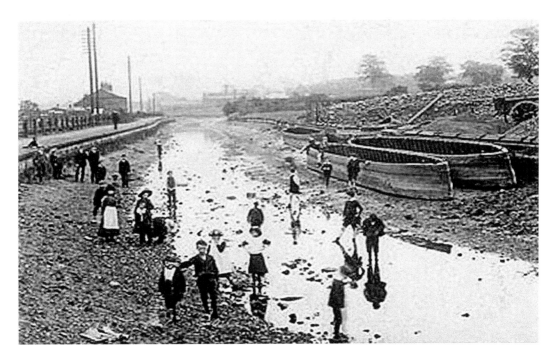

Lymm Breach

In this early twentieth-century photograph of the canal, it has been drained after a breach. What appears to be Lymm Tunnel can be seen on the far right. This part of the canal is now the home of Lymm Cruising Club. The club was formed in 1955 and has gone from strength to strength. The club soon outgrew the timber clubhouse and it was replaced by a more permanent building, which was designed and built by Lymm Cruising Club members.

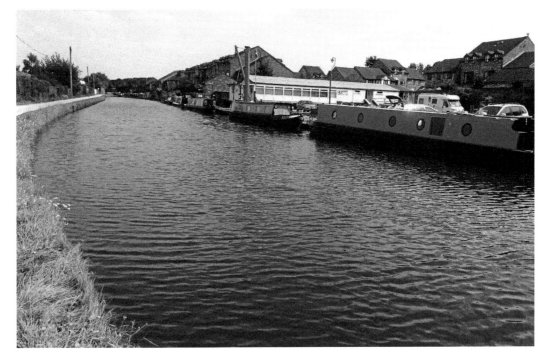

Lymm Brook Underbridge

This old illustration shows a very rural scene and the horse-drawn barge crossing over the road. The canal opened to here in 1770 and one year later to Stockton Heath. In 1861, *The Times* reported a serious breach of the canal. The embankment gave way and some cottages were flooded: 'The scene now presented is of a complete wreck.' One hundred navvies were needed to restore the canal and it was a month before traffic could be resumed.

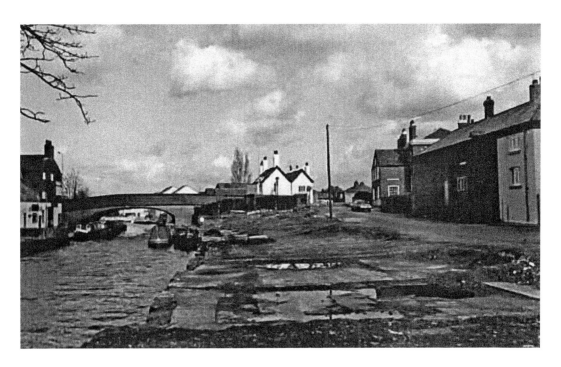

Stockton Heath, London Road Bridge

The canal was to change the area forever when it opened to Stockton Heath in 1771, separating Little Stockton Heath from Birchdale. London Bridge was a boarding place for the package boats to pick up passengers. The view today is little changed although the houses on the right are new and the London Bridge Pub was busy with customers sitting by the canal on the sunny day we visited.

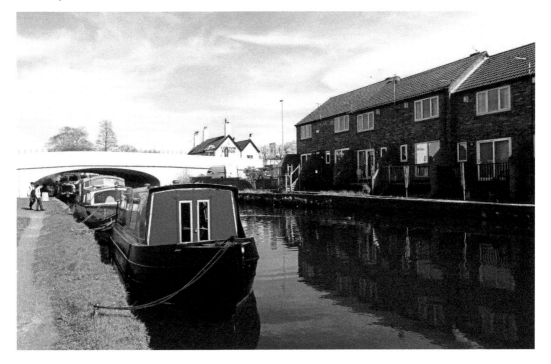

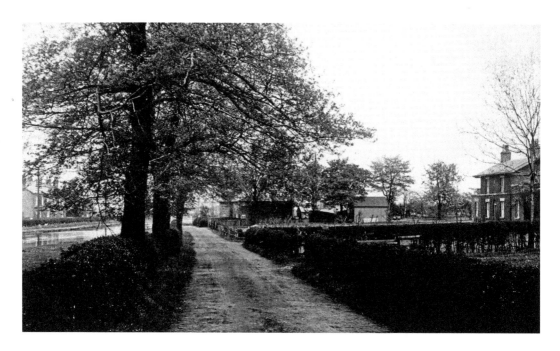

Moore Canal Side

An attractive view of the canal side. The canal at Moore became the home of 'Ken', who dropped out of society and chose the canal at Moore as his home. He was befriended by the good people of Moore. First he built a home of pallets, then he lived under a fishing umbrella. He was supplied with food and became a familiar site at Moore until his sad death in 1984. He is still remembered in Moore with affection.

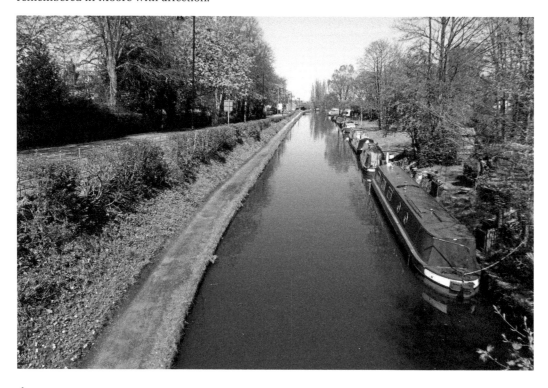

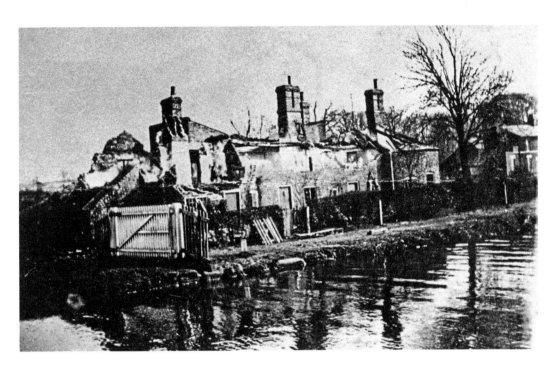

Moore Canal Side Fire

These cottages were destroyed by fire in 1907. On 19 March, the *Manchester Guardian* reported that 'Four thatched cottages were totally destroyed. A spark from a passing steam tug set one of the roofs on fire. Fanned by the gale, the flames spread rapidly until all the buildings were a burning mass.' No such dangers today along the canal at Moore from the diesel narrowboat *Jacob* from Manchester.

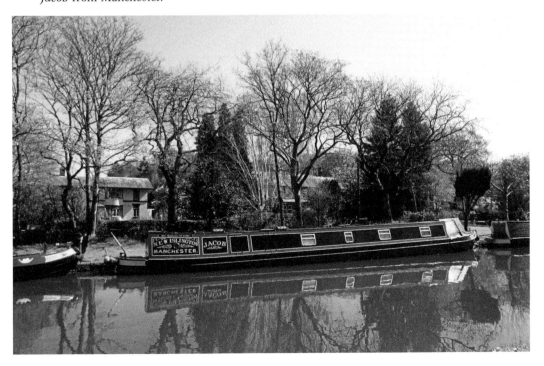

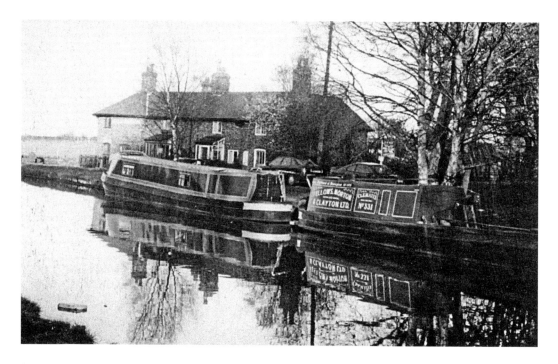

Moore Cottages

Clematis was built in 1934 for Fellows Morton and Clayton by Yarwood's. It was first registered in Birmingham. Moore had a busy coal wharf, which ceased to exist seventy years ago, but a barge was still delivering coal to the residents of Moore until quite recently. This surely must be the only village in Britain to have three completely different canals running parallel to each other with no waterway link connecting them – the Bridgewater, the Manchester Ship Canal and the old Runcorn to Latchford Canal.

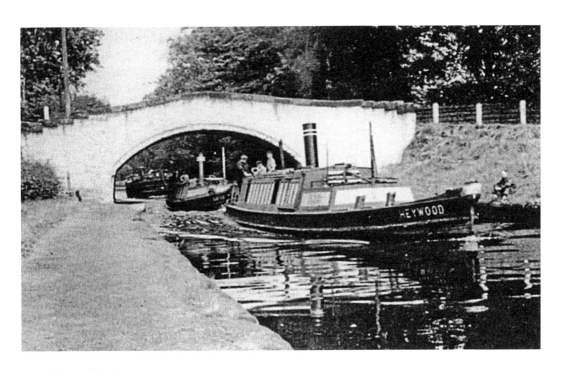

Moore Bridge

This picture features the little packet *Heywood* after its conversion to diesel in 1928. It was built in 1876 at a cost of £760. The builders were Richard Smith and Marshall & Sons. Sadly it was sold and scrapped in 1951. These craft were known as little packets. They were not strictly narrow steamers but varied in beam between 7 feet 10 inches and 8 feet 9 inches.

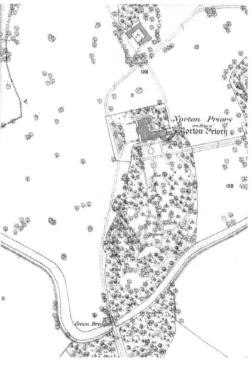

Green Bridge, Norton

The route of the canal here passed through the estate of Sir Richard Brooke, who vowed to oppose the canal. He was appalled at the thought of boatmen poaching his game and wildfowl, and did not want to see unsightly canal workers anywhere near his land. Sir Richard showed no sign of relenting even when works were largely completed and the Runcorn locks were opened in 1773. The map of 1862 shows the dramatic diversion of the canal at Norton.

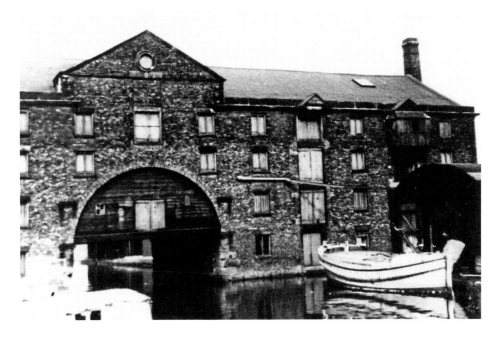

Preston Brook, Norton Warehouse

These warehouses and transit sheds dominated the canal at waters meeting where the canal splits towards Runcorn and south to Preston Brook. We can see the influence of the warehouses at Castlefield. They are designed to make loading and unloading easier by allowing boats to pull inside to be loaded under cover. Ahead is the Preston Brook tunnel giving access to the Trent and Mersey canal. The original plan was that transhipment should be done at Middlewich but the tunnel was built too narrow for Mersey flats. To solve this problem, many wharfs and warehouses were built at Preston Brook, making it a very busy inland port.

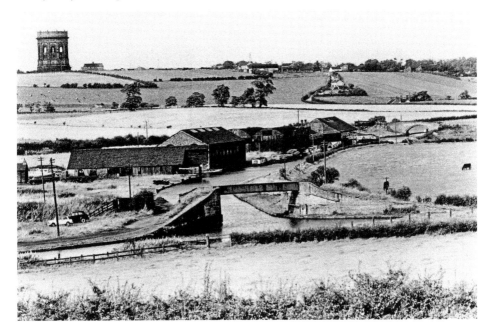

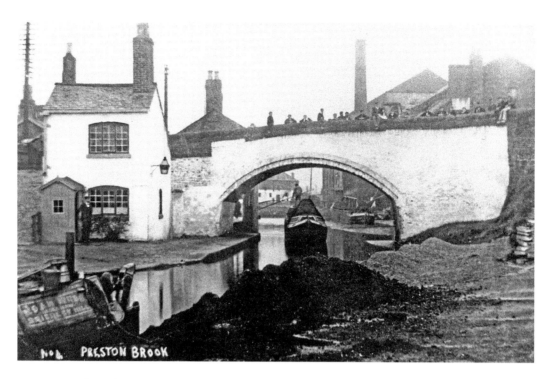

Preston Brook Bridge

A view of the old bridge and the old canal office. The children above have a good view. Through the bridge you can see the busy wharfs and warehouses, including the North Staffordshire. Most of these are now demolished. The bridge has now been rebuilt and we now see the very busy Claymore Yard, where you can hire a boat and even embark on a narrowboat holiday.

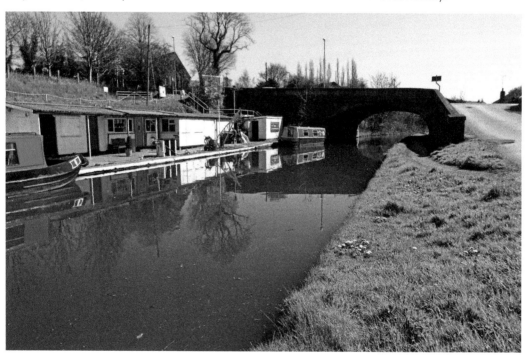

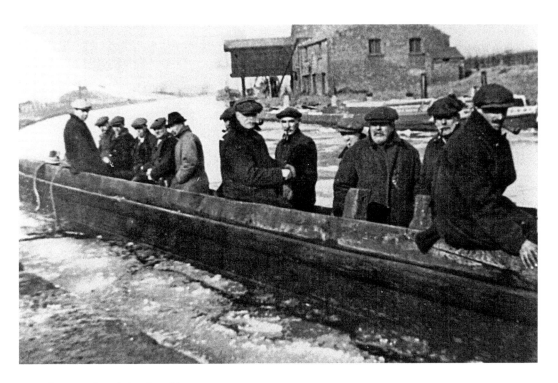

Preston Brook Ice Breaking

The canal iced up near the Old No. 1 Warehouse. Ice was a major problem in the winter. The icebreakers had specially strengthened sides and they were rocked from side to side by a strong crew of special men who could work in these conditions. Indeed, this photo shows them to be hard men. Below is Roy Gough's photo of the canal in winter, again near the Old No. 1.

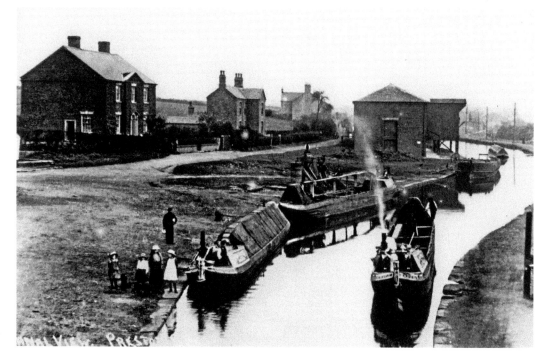

The North Staffordshire Warehouse (known as the Old No. 1)
Built around 1772, this is one of the few warehouses still standing today. It is well known in Runcorn as it later became a restaurant and a nightclub – it is now fine apartments. The canal side was very busy with warehouses and cranes loading and unloading. Coal arrived from Worsley, pottery arrived from Stoke and barges would return with china clay and stone. Bagshaw's directory of 1850 lists the many different carrying companies, including Anderton's, Pickford's and Crowley's.

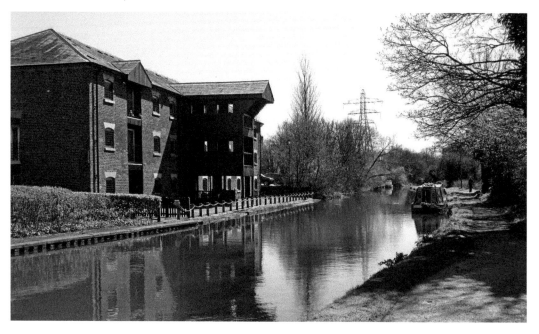

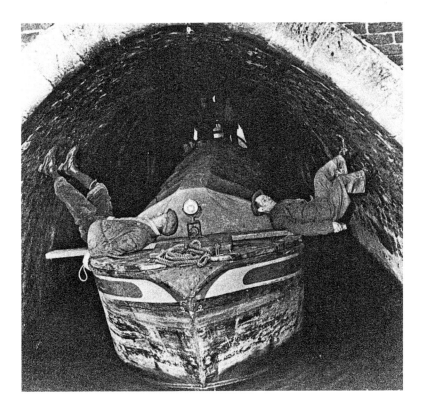

Preston Brook Tunnel and Leggers

For almost 100 years, all boats were horse drawn and were 'legged' through the tunnel. However, in 1865 steam tugs were introduced, but the tunnel had no air vents, resulting in a number of boatmen being overcome by fumes and dying. Very soon, ventilation shafts were sunk. The junction of the Trent and Mersey Canal with the Bridgewater Canal is actually located about 6 to 10 yards inside the northern end of Preston Brook Tunnel, and is roughly marked by the '0' milepost on the towpath above the tunnel mouth.

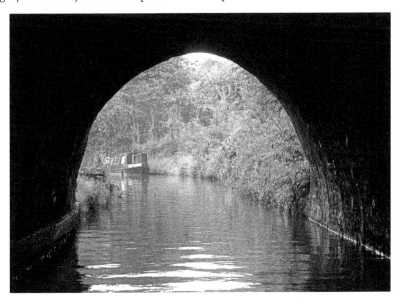

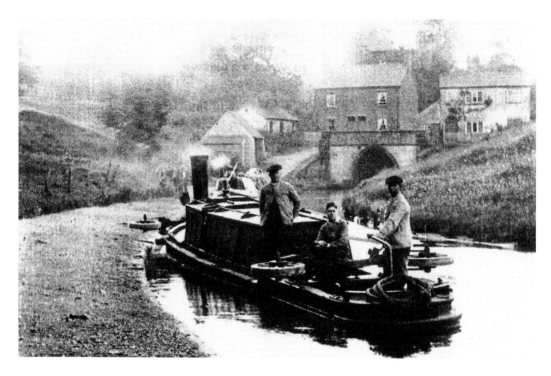

Preston Brook Tunnel End, 1933

Here is a Preston Brook tug at the southern end of the tunnel. It shows the side-mounted wheels these helped steering in the tunnel. This is Tug No. 1 usually acting as the spare. Tug No. 3 was bigger and could only work Preston Brook. Crew members were George Lightfoot, Ernest Clare and Fred Higgins. Originally the junction was at the northern end of the tunnel, but the tunnel was extended slightly when the tunnel keeper's house was built.

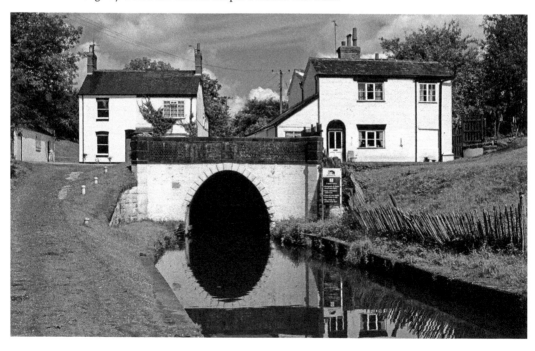

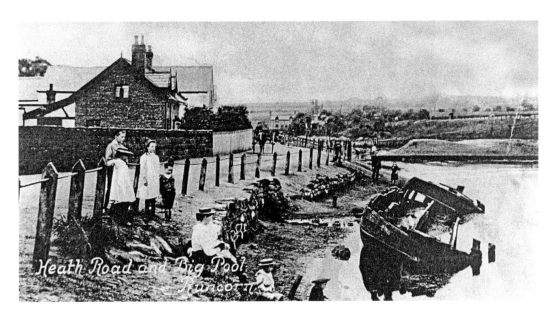

Runcorn Big Pool

A charming photo of the big pool, although the barge is looking very sad. Most of this pool has been drained but it is said there are numerous barges lying below. The canal originally swung around a sharp bend next to this big pool beside Heath Road, a natural lake that Brindley took advantage of when constructing the canal. The map shows the route and also the Albion boatbuilding yard – a competitor to the more famous Sprinch yard.

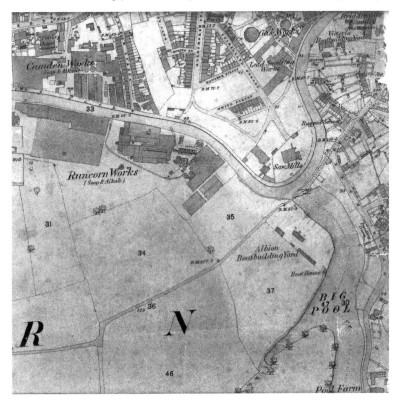

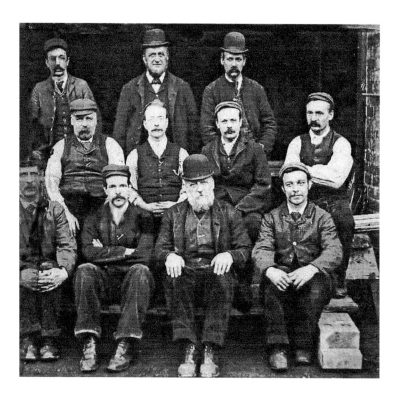

Runcorn Sprinch – Victoria Dockyard

A fine photo of these proud craftsmen at the boat yard. The Sprinch yard was founded in 1890 and was a successful and busy yard. It was once responsible for the maintenance of over 200 canal craft. Fire destroyed the storerooms in 1935, which were never rebuilt. The yard closed in 1948 when the tradition of building and repairing canal craft died out in Runcorn. The original dry dock and slipway are still used by the Bridgewater Motor Boat Club.

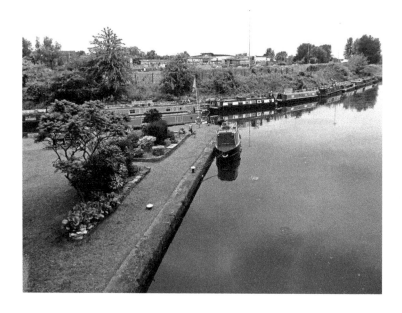

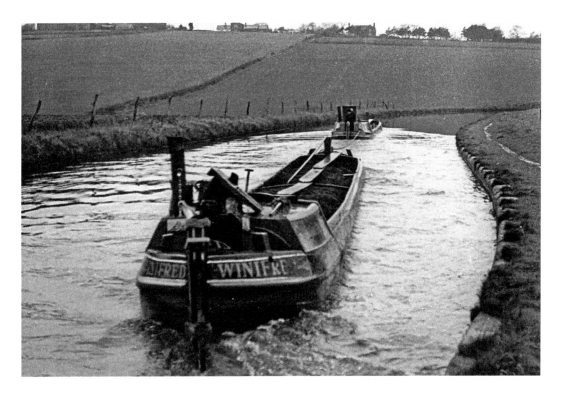

Barges, Runcorn

Here we see *Winifred* on the Bridgewater in 1956. The Horsefield boats were a familiar sight on the canal at Runcorn. They had a large number of horses, which were stabled by the canal. As we were researching the company, we came across a report from Leigh Municipal Borough Health Inspector, who inspected each boat to ascertain its general condition and that of any living quarters on board. In 1948 Horsefield's were cautioned for failure to produce an adequate registration certificate for *Winifred*.

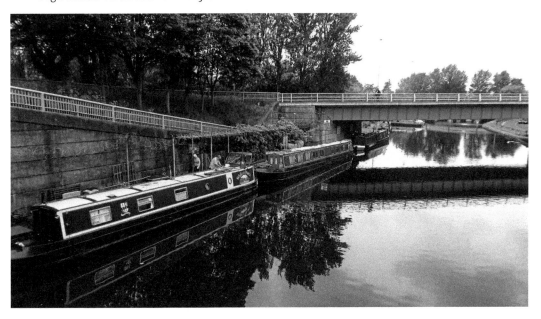

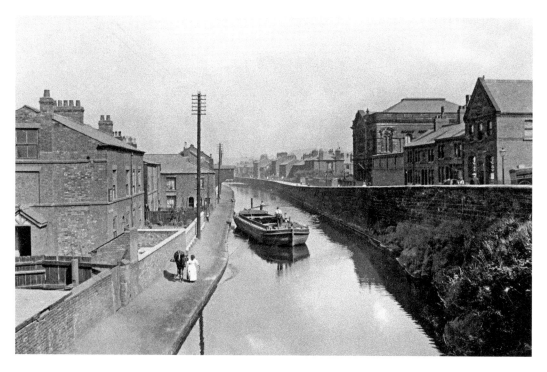

Halton Road from Delph Bridge, Runcorn, 1899

A fine view of the lady guiding the horse-drawn barge towards the bridge. We also see the fine Wesleyan chapel on Halton Road, built by Thomas Hazlehurst in 1871, now long gone. Halton Road was the main road to Warrington. This stretch of canal was always crowded with narrow boats berthed and waiting to be unloaded at the various works, their horses stabled in the large stables owned by the Horsefield family. The modern view is rather spoilt by overhanging trees.

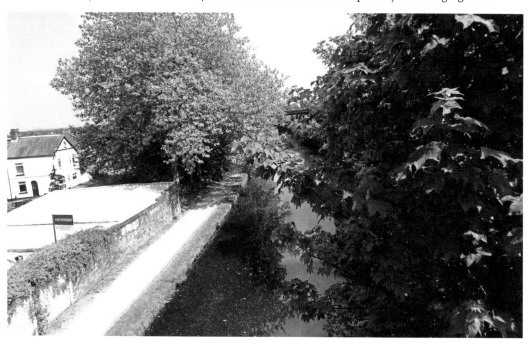

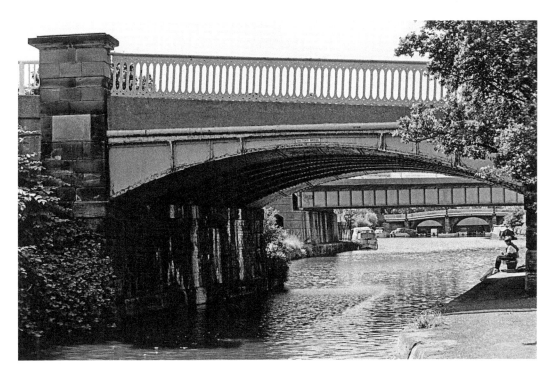

Three Bridges, Runcorn

A view through three bridges towards Top Locks. First called Doctors Bridge, it was renamed Runcorn Bridge until the 1890s. Possibly the name was changed to avoid confusion with the nearby railway bridge of the same name that crosses the Mersey. To add to the confusion, it was also known as Savage's Bridge – Savage's had the butchers shop just off the bridge. Next is Runcorn–Widnes Bridge, Approach Road and finally the blocked-off Waterloo Bridge.

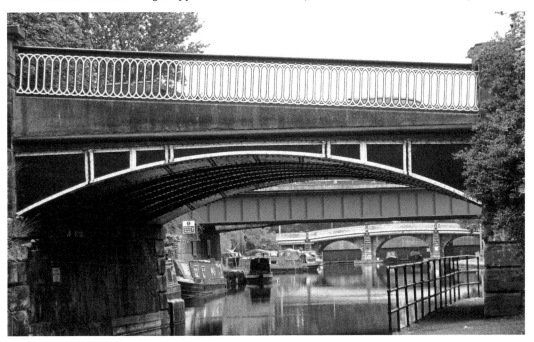

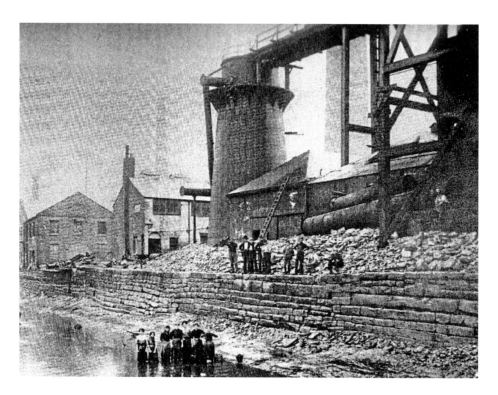

Canal Pickings, Runcorn

Women and girls dredging for coal from the canal floor. This was a familiar sight when the canal was being drained for maintenance work. This photo shows the canal by Runcorn Soap & Alkali Works. It was the largest works in Runcorn and one of the largest producers of alkali in the region. The heavy industry is long gone and the canal here looks far more peaceful today.

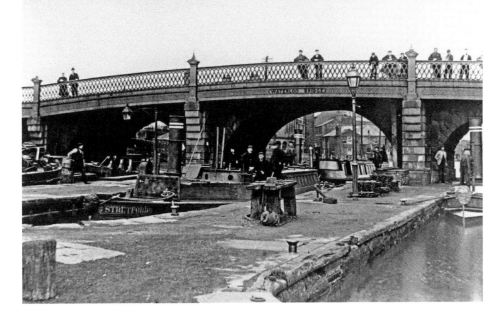

Waterloo Bridge, Runcorn

The *Stretford* moving under the bridge towards Bottom Locks. It was built in 1875 for £702 and later converted to diesel. This image demonstrates how busy the canal was at Runcorn and what a spectacle it was to watch the barges going down the line of locks. The centre arch gave access to a dry dock. Sadly, the modern photo shows the bridge boarded and access to the locks no longer possible. There are ambitious plans to open up the old line of locks.

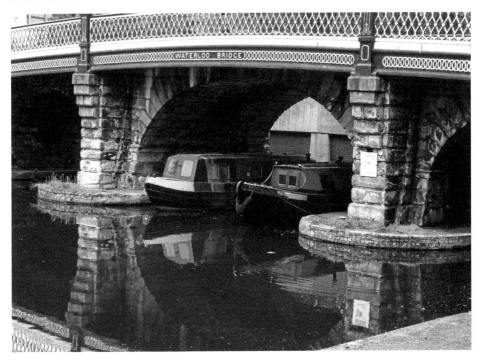

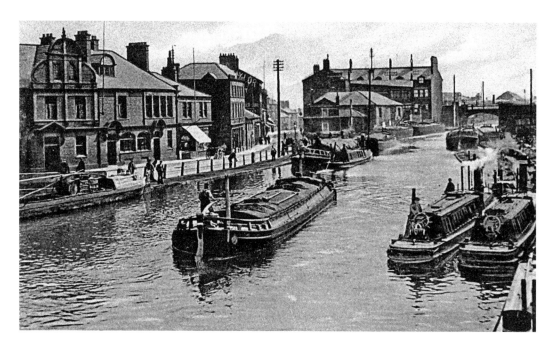

Top Locks, Runcorn, 1905

A busy view of Top Locks taken from Waterloo Bridge. The locks were a wonder of their time. The duke was fortunate that here at Runcorn the quarries could provide the excellent stone, which was ideal for construction of locks and basins. When Josiah Wedgewood visited in 1773, he declared them 'truly wonderful'. We see Doctors Bridge beyond. On the left is the Waterloo, which has now become a Buddhist temple. A road bridge now crosses the canal here.

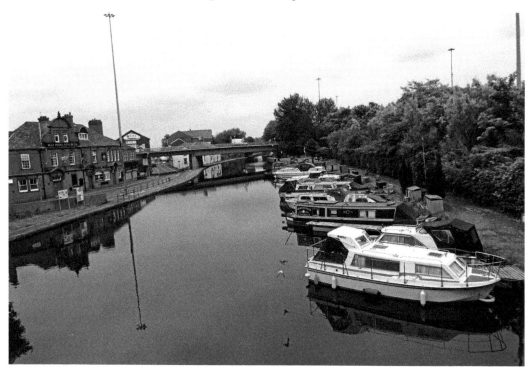

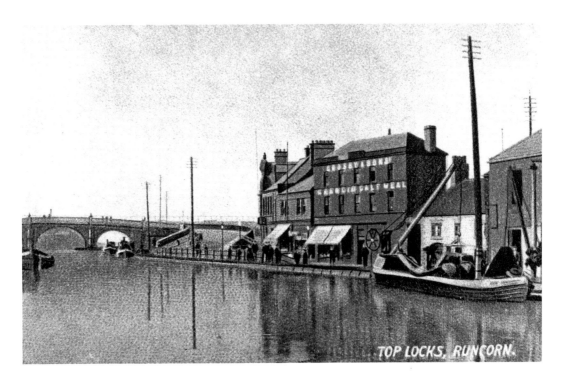

TOP LOCKS, RUNCORN.

Top Locks, Runcorn

Another view of Top Locks looking towards Waterloo Bridge. Although the canal was built for the transport of freight, the duke realised the potential for passenger traffic. He started a service between Stockton Heath and Manchester, soon extending a service to Runcorn. The journey from Top Locks to Manchester took eight hours and could accommodate 100 people. The packets started at Top Locks but picked up at Delph Bridge and occasionally the duke himself travelled on his boats.

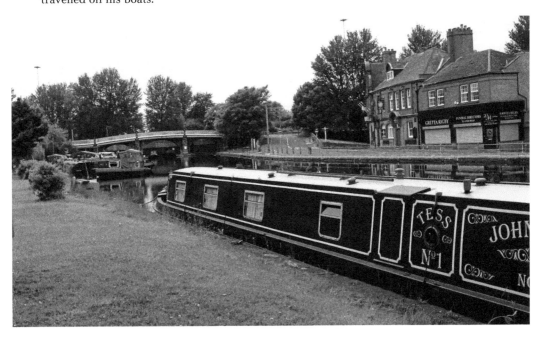

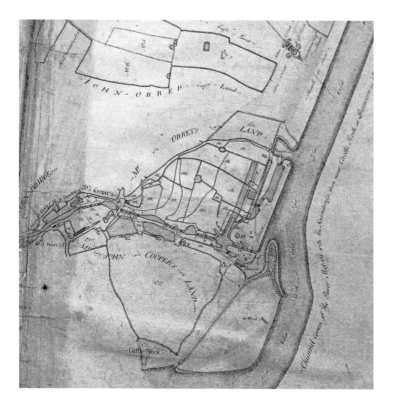

Runcorn – Foulkes Map, 1785

This extract shows the first line of locks leading down from Runcorn Bridge. It also shows the land ownership at the time. John Orred was a major landowner in Runcorn and he agreed a considerable sale in 1790. With the building of these locks, the duke and James Brindley had made the transport of goods possible from the River Mersey to Manchester. They also allowed for the flats coming from the duke's facilities across the estuary at Liverpool Docks.

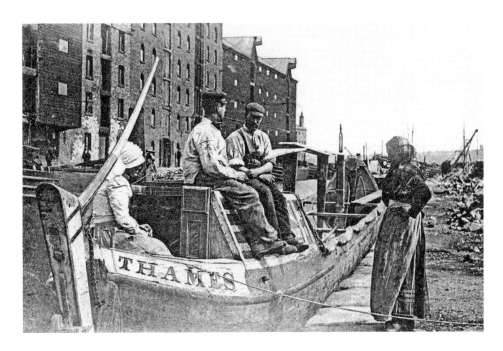

Bottom Locks Warehouses, Runcorn

The Anderton Company narrowboat *Thames* at Bottom Locks around 1908. Below, the 1862 map illustrates the new and old line of locks and the docks. Over the years, the canal fell into disuse, culminating in both lock flights being filled in around 1965, the time of the building of the Runcorn–Widnes Road Bridge. The Runcorn Locks Restoration Society (RLRS) was formed in 2004 to champion the restoration of the locks.

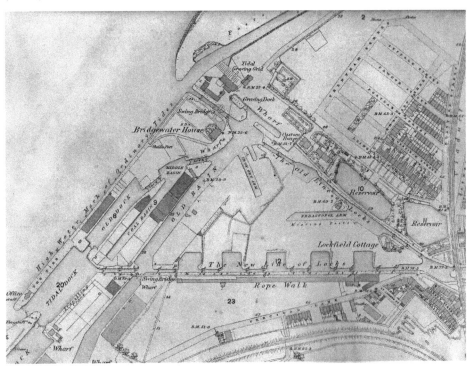

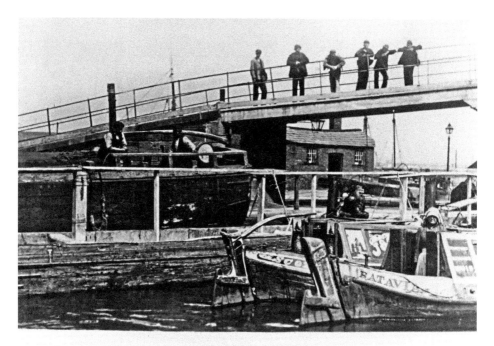

BOTTOM LOCKS. RUNCORN

Bottom Locks, Runcorn

Batavia at Bottom Locks creating a fine view for the men on the bridge. The first line of locks became so busy that another flight of ten individual locks was constructed to provide a parallel route, becoming known as Runcorn New Locks, while the original flight became known as Runcorn Old Locks. The old custom house built in 1874 is in the background. Sadly, the custom house is long gone and we see all that is left of the locks.

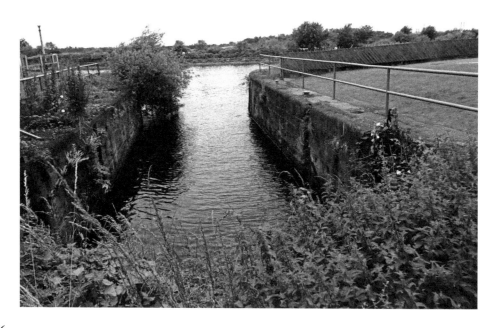

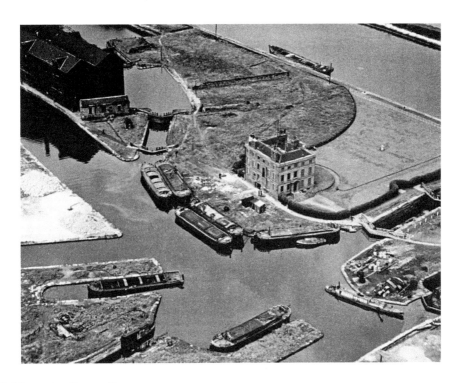

Bridgewater House, Runcorn

An aerial view of the building. It was built in 1771 near the lower end of the line of locks. It was built by the duke to act as his residence when he was supervising the building and operation of the Runcorn branch of the canal. The duke took a keen interest in the everyday activities of his waterway and was often seen in Runcorn, often quite grimy after watching the unloading of coal barges. The fine building still stands today.

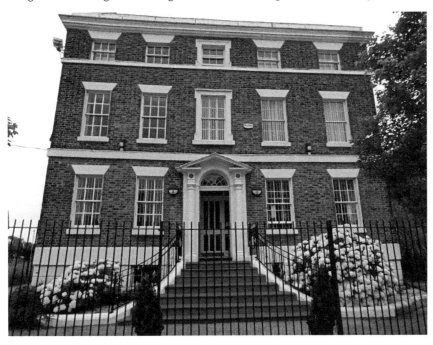

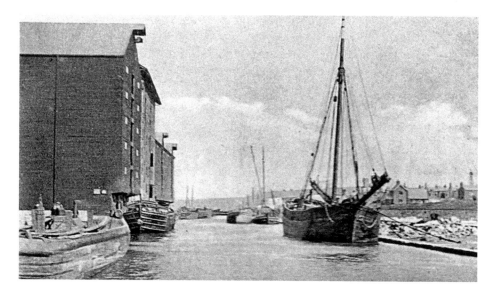

Francis Dock

Runcorn was originally part of the Port of Liverpool. Francis Dock was opened in 1843 to cope with the ever-increasing trade at Runcorn. Pressure for independence from Liverpool at last resulted in Runcorn becoming an independent port in 1847. Francis Dock was later joined to the River Weaver Navigation and is still in use today as part of Runcorn Docks. Today, the docks at Runcorn have been streamlined and are still important for the bulk storage of minerals; they also offer a transfer facility to road haulage for onward delivery by trucks. The 1862 map below shows the dock with the end of the new line of locks in the top-right corner.

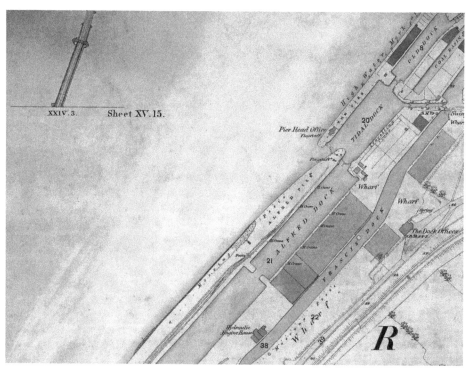

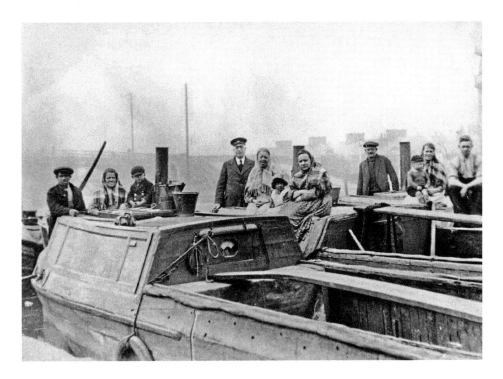

Canal Families, Runcorn

Life was hard for families on the canal but it was a unique community and a way of life. Most did not own their boats and were paid trip money. Only the captain received wages so usually his wife and family crewed for him. When the boat was idle or the horse was injured, then no money came in. The modern picture shows members of the Suitcase Ensemble recreating life on the canal at the Canalival in Runcorn in June 2016.

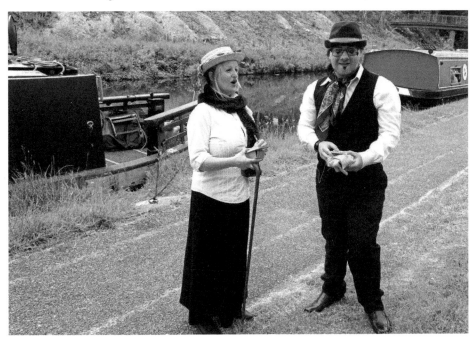

WORSLEY, Nov. 11, 1837.

SIR,

I have to request that Directions may be given, to enforce Mr. Bradshaw's REGULATION against Flatmen's and Lightermen's WIVES living and sleeping on board with their Husbands.

In explanation of this Order, I want it to be stated, that the existence of such a practice, besides affording many excuses for depredation, leads to a system of Morals extremely detrimental and therefore to be avoided.

I am, your obedient Servant,

JAMES LOCH.

G. S. FEREDAY SMITH, Esq.
Bridgewater Canal Office,
Manchester.

MANCHESTER SHIP CANAL COMPANY
(BRIDGEWATER CANALS UNDERTAKING).

RATES OF WAGES to be paid to the CREWS of the COMPANY'S NARROW BOATS working on the BRIDGEWATER CANAL, operating on and from AUGUST 31st, 1891.

Schedule of Wages paid to Crews of Narrow Boats

Supervising Life on the Canal

James Loch was appointed superintendent of the canal in 1837. This order shows he lost no time in dealing with the moral welfare of the boat people. The welfare of the children was also causing concern. A report of boat children in 1884 showed that there were 151 children of school age on 363 boats and only thirty-two could read and write. In 1875, a seaman's mission was opened in Runcorn to improve the lot of boat children. Above, we see the wages payable in 1891.

" A seaman's and boatman's mission room has been opened at Runcorn, and a large notice board put up at the entrance of the room. 'Notice—Seaman's and Boatman's Mission Room. Service on Sunday evenings at half-past six o'clock. Sunday-school for children : morning nine o'clock, afternoon, two o'clock.' This was surely not before it was wanted ; for the agent writes me, under date December 7, 1877, that he cannot find *any* of the boat people are able to read, and he meets with many of the families on board the canal boats living in the lowest depths of vice. It is different with the flatmen, who live in dwellings on shore, they have the privilege of attending a place of worship on the Sabbath day, and their children are sent to the Sabbath school, where they are taught to read the Bible.

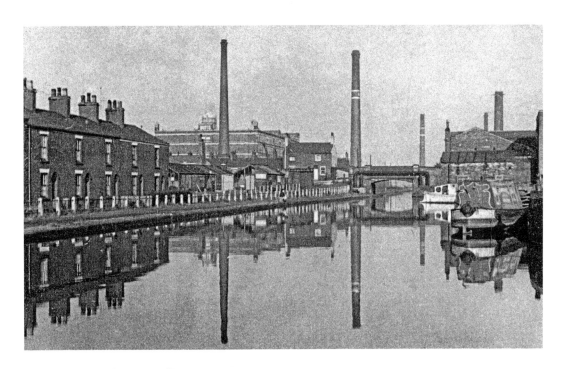

Leigh Canal, Butts Mill

The Leigh extension was opened in 1799. It was 5 miles long and, like the rest of the Bridgewater Canal main line, had no locks. This branch was to prove important because it was a means of transferring coal from the Mosley Common Collieries to the basin on the Bridgewater Canal. The construction of the Leeds and Liverpool Canal and its connection to the Leigh branch further emphasised the importance of the Bridgewater Canal as a catalyst for the development of the country's waterways transportation system. This view towards Butts Bridge shows the famous Butts Mill, a cotton-spinning mill designed by Stott & Sons of Oldham. The houses still stand today but are hidden by trees and the Butts boat basin on the right is still busy today.

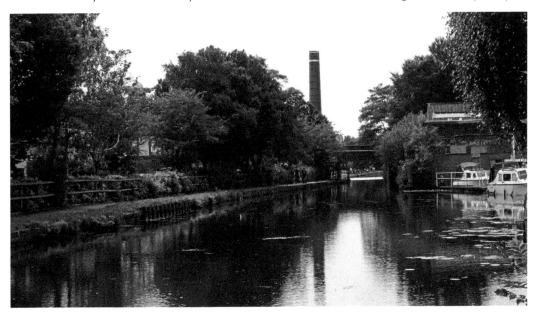

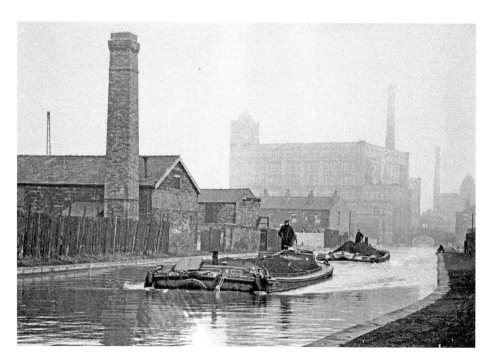

Leigh Canal at Mather Lane

Two barges approaching Mather Lane Bridge. It was known as Dick Mathers Bridge, which was named, according to local legend, after a schoolmaster, Richard Mather, who drowned himself in a pit near to where the bridge now stands. Mather Lane Mill dominates the centre of the photo. It looks today like renovations are in progress.

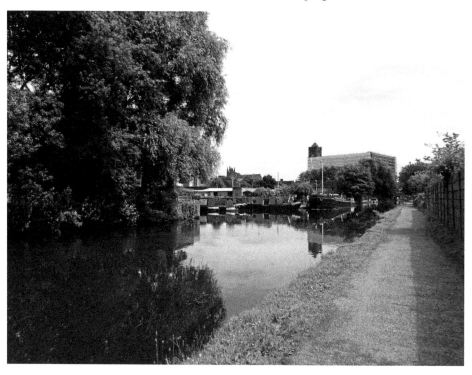

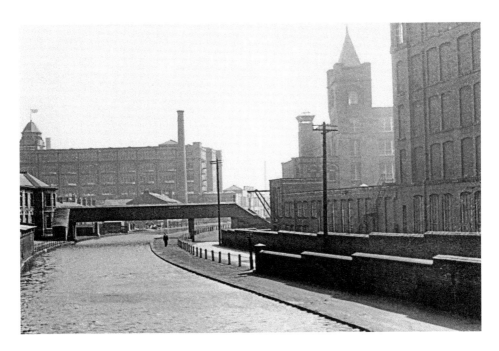

Leigh Canal Looking Down From Mather Lane Bridge

We see Brooklands Mill and Hall Lane Mill. It was so called because it was originally supposed to be built near Hall House Lane, off Manchester Road. Instead, a site was chosen just south of Mather Lane Bridge next to the already existing Mather Lane Mill. The contract for the six-storey mill was awarded to Taylor Brothers of Littleborough, who had just completed the building of Manchester's Victoria Station. The ironwork and pillars were cast by the Hindsford Foundry.

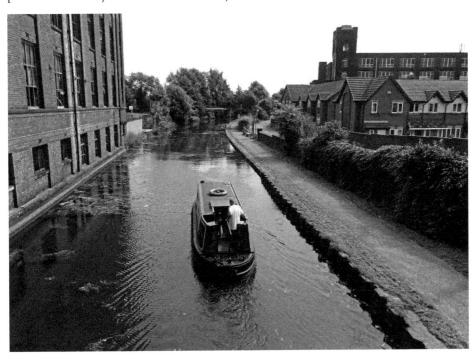

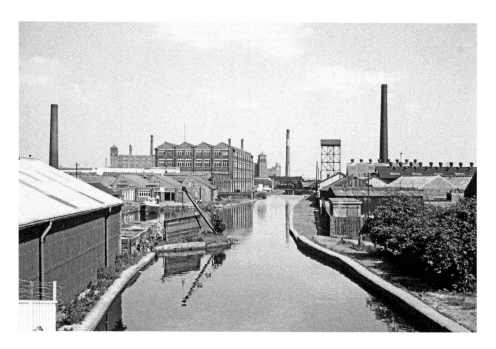

Leigh Canal from King Street Bridge

This is the end of the canal and the start of the Leeds and Liverpool Canal. The view towards Mathers Lane Bridge shows the importance of the textile industry to Leigh. The town's industrial past can be seen in the many red-brick mills, some of which still stand today. Over 6,000 people were employed in textiles in Leigh in 1911. Fine apartments have been built on the site and the crane has been lovingly restored.

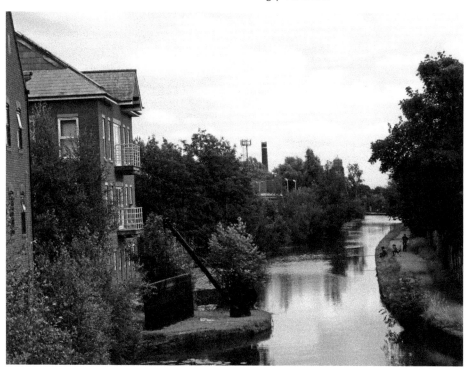

Acknowledgements

Once again, our grateful thanks to Roy Gough for allowing us to use some of his photographs and for his help and encouragement. Thanks also to Cyril J. Wood for allowing us to use his photographs of Lymm and, of course, his extensive knowledge from his books and websites.

As a local librarian, I am always impressed with help we receive from local history societies and their work in preserving local heritage.

We could not have managed without the help of the Runcorn Historical Society, the Preston Brook & District Local History Group and the Daresbury and District Heritage Group.

Thank you to Manchester Archives, Salford Local History and Archives, Wigan Local History and the Peel Group.

Bibliography

Cyril J. Wood, *The Duke's Cut: The Bridgewater Canal* (The History Press, 2002).
Bernard Falk, *The Bridgewater Millions* (Hutchinson & Co., 1942).
Manchester Ship Canal Company, *Bridgewater Canal, Bicentenary Handbook*.
H. F. Starkey, *Old Runcorn* (Halton Borough Council).

About the Authors

Jean managed the local history collection in Runcorn and Widnes library for many years. She has also created the image website for Halton (www.picturehalton.gov.uk). She has published a number of heritage walk leaflets for Halton Library Service and is currently producing an oral history of Halton.

Recently retired, Jean is an adult tutor, offering courses in family history.

John has numerous production credits in theatre, television and film. Ex-BBC and Granada, he has worked mainly for the last decade in portrait, film and artscape photography.

Their previous publications include *Widnes Through Time, Cheetham Hill, Crumpsall, Blackley and Moston Through Time, Runcorn Through the Ages* and *Central Manchester Through Time.*